KALILA WA DIMNA

Sulayman Al-Bassam

KALILA WA DIMNA

or

The Mirror for Princes

OBERON BOOKS
LONDON

First published in 2006 by Oberon Books Ltd
521 Caledonian Road, London N7 9RH
Tel: 020 7607 3637 / Fax: 020 7607 3629
e-mail: info@oberonbooks.com
www.oberonbooks.com

A catalogue record for this book is available from the British
Library.

ISBN: 1 84002 670 7

For Sheikha Hussa,
…In herself, a Mirror for Princes

AL-MANSOUR'S BAGHDAD (762 AD)

The Abbasids
(750–1258)

The second of the two great Sunnite dynasties of the Islamic Caliphate, the Abbasids took their name from an uncle of the Prophet Muhammed, Al-Abbas, whose descendants formed one of several groups agitating for change under the Ummayid dynasty. The Ummayid enforcement of a brand of Arab chauvinism, wherein non-Arab Muslims were relegated to a lower status, led to a revolution in which the Abbasids claimed the Caliphate and enforced a more universal community of believers. This was symbolized by their movement of the caliphal capital from Damascus to Baghdad, an area closer to the geographic centre of the empire and nearer the Persian hinterland. Under their rule, Islamic culture flourished, new heights in philosophy and science were attained, and the period was widely seen as the 'golden age' of the Islamic world.

<div align="right">From the Encyclopaedia Britannica</div>

Author's Introduction

THE EVENTS OF THIS PLAY take place in the period between the dawn of the Abbasid Revolution (750 AD) and the date of Ibn Al-Muqaffa's murder (circa 759–62 AD). We are, therefore, at the very beginning of the creation of an Empire that was to last for almost four centuries. The famous heights of luxury and intellectual prowess achieved during the period of Harun Al-Rasheed are still nothing more than ideas on the distant horizon (Al-Rasheed was Al-Mansour's grandson). The period dealt with here is one marked by great internal turmoil as the rulers jockey for power, settling their scores within the Abbasid line itself, whilst the momentum of the Revolution turns itself upon both its fathers and children.

The play is, on its surface, a historical one; but there are a number of contemporary concerns that I have tried to address through it. Ibn Al-Muqaffa's fate, far from being confined to the comfortable realms of dramatic metaphor, is one that awaits to this day – in various degrees of cruelty – writers, thinkers and journalists at odds with authority in many parts of the Middle East. Furthermore, Iraq is again today a theatre witnessing the birth pains and death throes of empires. All empires need stories; and as our modern-day 'Colossus' takes hold of the Middle East, toppling and restructuring in its path many regimes that were, in their turn, put in place by the waning imperial powers of less than a century ago, this play is an exploration of the relationship between power and its narratives.

In its form, canopy of characters and narrative shape, the play has an obvious debt to Shakespeare, whilst its language is inspired by the vigour and muscularity I gleaned in the original Arab sources (Al-Tabari, Al-Jahashiyari), re-imagined into modern English.

Finally, through writing this piece of Arab and Islamic history in English, I hope to add a small pinch of 'mental benzene' to that area of inter-cultural dialogue which allows for a keener perception of Self through the eyes of the Other.

<div align="right">

Sulayman Al-Bassam
Kuwait, April 2005

</div>

Note The play is by no means an accurate historical document and should not be regarded as such. Though drawing on several historical sources for the events of the piece, I have allowed myself large swathes of liberty in both the portrayal of characters and events.

An asterisk in the text denotes an entry in the glossary (p94).

Characters

The Rulers

AL-SAFFAH	1st Calipha of Abbassid Dynasty (Abu Al-Abbas Al-Saffah 750–4 AD)
AL-MANSOUR	Al-Saffah's elder brother; 2nd Abbassid Calipha (Abu Ja'afar Al-Mansour 754–75 AD)
ABDULLAH BIN ALI	A General; Al-Mansour's uncle
ASIA	His daughter; Al-Mansour's cousin.
SULAIMAN BIN ALI	Governor of Basra, Al-Mansour's uncle and brother of Abdullah
ABU MUSLIM	Military High Commander of the Abbasid Revolution (Abu Muslim Al-Khurasani d. 755 AD)

The Courtiers

ABU AYYOUB	Court Scribe and advisor to Al-Mansour (Abu Ayyoub Al-Mooryani)
SUFYAN	Courtier of Al-Mansour, later Governor of Basra (Sufyan Bin Mu'awiyya Bin Muhallab)
RABIH	Al-Mansour's chamberlain (Al-Rabih Bin Yunis)

The Writers

ABDUL HAMEED	Teacher and friend of Ibn Al-Muqaffa (Abdul Hameed Al-Katib d. 750 AD)
IBN AL-MUQAFFA	Court scribe and writer (Rawzabah, later 'Abdullah', Ibn Al-Muqaffa, d. circa 760)
BASHAR	A blind poet, friend of Ibn Al-Muqaffa (Bashar Ibn Burd)
WALIBA	A poet and, later, a courtier (Waliba Bin Habbab)
ABRASH	(The Speckled One) A palace eunuch, Ibn Al-Muqaffa's servant

The Animals

JACKAL	An orchestrator
	Slaves, soldiers, assasins

This play received its world premiere at the Tokyo International Arts Festival, in Japan, on 10 March 2006. This production was co-produced by:

Dar al-Athar al-Islamiyyah, Kuwait; Tokyo International Arts Festival, Japan; bite06, Barbican, UK

◆東京国際芸術祭 ‖‖bite06 *State of Kuwait* ARTS COUNCIL ENGLAND

The UK Premiere was presented by Sulayman Al-Bassam Theatre as part of bite06 at The Pit Theatre, Barbican, London on 10 May 2006, with the following cast and creative team:

SUFYAN, Nigel Barrett

ASIA, Michelle Bonnard

JACKAL, Ben Boorman

ABU AYYOUB, Kammy Darweish

IBN AL-MUQAFFA, Neil Edmond

ABDUL HAMEED / ABDULLAH BIN ALI, Mark Jax

AL MANSOUR / BASHAR, Simon Kane

SULAIMAN BIN ALI / ABU MUSLIM, Nicholas Khan

ABRASH / AL-SAFFAH / WALIBA, Matthew Parish

Musicians, Lewis Gibson, Alfredo Genovesi

Slaves, Soldiers, Assassins, Animals, The Cast

Writer and Director, Sulayman Al-Bassam

Set and Costume Designer, Julia Bardsley

Lighting Designer, Chahine Yavroyan

Composer and Musical Director, Lewis Gibson

Assistant Director, Nigel Barrett

Assistant Designer and Masks, Philippa Van Welie

Production Manager, Dominic Martin

Company Stage Manager, Vicky Berry

Assistant Stage Manager, Ben Boorman

Surtitles Director, Wafa'a Al-Fraheen

Script Editor, Georgina Van Welie

ACT ONE

SCENE 1

Basra.

Inside IBN AL-MUQAFFA's house.

In the distance we hear sound of men chanting and women screaming.

ABDUL HAMEED: I am terrified. I am so terrified.

IBN AL-MUQAFFA: Then you are Abdul Hameed the Writer still!

ABDUL HAMEED: Is your man on the roof?

IBN AL-MUQAFFA: Writers are good for three things: being cowards during wartime; slanderers during peace and sat at the King's table during famine! This is not a war, it's a little revolt, a mere bashing of heads, an utterly minor affair.

ABDUL HAMEED: The Tigris has been choked with blood for three days and you call this –

IBN AL-MUQAFFA: In the scale of things, I mean.

ABDUL HAMEED: Al-Damashqi beheaded, Abu Ala'a dragged through Kufa, quartered, his mouth slit from ear to ear –

IBN AL-MUQAFFA: Will you believe every tongue that wags?

ABDUL HAMEED: And what were they to Marwan*? Pen-pushers, clerks!

IBN AL-MUQAFFA: Your partridge is getting a chill. I think it rather rude considering the quality of the honey I've been basting it in.

ABDUL HAMEED: This is terrible, I'm shaking, I cannot control my limbs! What the hell are they chanting?

IBN AL-MUQAFFA: It's from the Koran.

ABDUL HAMEED: Can you make it out?

IBN AL-MUQAFFA: Those who rise up from oppression are those that God is with.

ABDUL HAMEED: Write it down. Cursed are the days that give birth to monsters! Cursed are the minds that give birth to monsters, cursed are the hours cursed are the eyes – write that down too – I cannot stop this wretched trembling!

The door is forced open.

…Oh God!

ABRASH: Hello Uncle! I brought you the carpet, where would you like it?

ABDUL HAMEED: My little speckled eunuch!

IBN AL-MUQAFFA: Little bugger terrified me!

ABRASH: All the way from the Calipha's palace.

ABDUL HAMEED: How did you find me?

ABRASH: How could I not find Uncle?

ABDUL HAMEED: Come let me kiss you. You've brought the tapestry you genius child, that's my speckled bird! Ibn Al-Muqaffa'! Give me some gold for this boy.

ABRASH: All the way from Al-Anbar, Uncle, crowds in every town are shouting, 'The oppressed have risen, the oppressed have risen'!

ABDUL HAMEED: The only thing that's risen is the price of whips, boy.

IBN AL-MUQAFFA: Stand outside Abrash, keep an eye out for the black flags of our so-called 'liberators'.

Exit ABRASH.

ABDUL HAMEED: You said you were working on animal fables?

IBN AL-MUQAFFA: Kalila wa Dimna.

ABDUL HAMEED: Here, then, are your animal tales wrought in finest Mervian silks.

IBN AL-MUQAFFA: What?

ABDUL HAMEED: It was a liberty from the Governor of Khurasan* to Marwan.

IBN AL-MUQAFFA: It is spilling with colour.

ABDUL HAMEED: Five year's worth of taxes in that. It is for you.

IBN AL-MUQAFFA: How can I thank you?

ABDUL HAMEED: Cling to life and write a prose that digs deeper into the mind than mine.

IBN AL-MUQAFFA: Take it back, then. Better prose cannot come from a pen in my lifetime.

ABDUL HAMEED: It can. From yours!

IBN AL-MUQAFFA: How?

ABDUL HAMEED: By dipping your pen in blood.

Enter ABRASH.

ABRASH: Uncle, Uncle! The black flags are on the minarets! The black flags are all over Basra*!

IBN AL-MUQAFFA: I suggest you move down to the cellar. I'll keep the partridge in the kiln for later.

ABDUL HAMEED: I'm trembling again, damn it, I can't move I'm so terrified!

The door is kicked down. Enter three Abbassid soldiers.

SOLDIER 3: Which of you is Abdul Hameed Al-Katib, scribe to the Dog of Umayyid dogs?

Simultaneously:

ABDUL HAMEED: } { It is I!
IBN AL-MUQAFFA: } { It is I!

SOLDIER 1: A parrot!

SOLDIER 3: With two heads!

SOLDIER 1: What then?

SOLDIER 2: (*Eating the partridge.*) Delicious.

SOLDIER 3: I'll bleed Abdul Hameed…

SOLDIER 1: I'll bleed Al-Katib!

ABDUL HAMEED: Stop! Look at my features, look at me well and you will know that I am the scribe you're looking for.

SOLDIER 3: Did Sufyan describe him?

IBN AL-MUQAFFA: Sufyan?

SOLDIER 1: He who gives life and takes it away.

IBN AL-MUQAFFA: You blaspheme your own God.

SOLDIER 3: What do you know of God, fire worshipper?

SOLDIER 2: Enough! Show us your right hand. Both of you.

Both raise their hands.

SOLDIER 1: (*Indicating ABDUL HAMEED's hand.*) Look how it trembles!

SOLDIER 2: His whole frame is trembling – it's him!

IBN AL-MUQAFFA: Wait, it's me, take me!

SOLDIER 2: Lovely honey on that bird!

They exit with ABDUL HAMEED, we hear a cry of pain from without.

SOLDIER 2 opens the door and throws ABDUL HAMEED's severed hand onto the carpet.

ABRASH: It's Uncle's hand! Uncle! Uncle!

IBN AL-MUQAFFA: Don't touch it, boy!

SCENE 2

The Mirbid, town square in Basra.

SLAVES scrubbing the town square of blood, preparations for a large party.

SUFYAN: Scrub the blood according to the pattern.

SLAVE: I am cleaning the square, my Lord.

SUFYAN: I don't want a clean square! Read the pattern!

SULAIMAN BIN ALI: Is this blood thing absolutely essential, Sufyan?

SUFYAN: This is enemy blood, my Lord, a most ruby-precious Ummayid red.

SULAIMAN BIN ALI: Keep scrubbing, young man.

SUFYAN: You can't just throw pales of water at it. Stop, slave!

SULAIMAN BIN ALI: Does it really matter what pattern they draw?

SUFYAN: You're the one who wanted it to be an aesthetic gesture! And as it is for the Leader of the Faithful himself, my lord, I don't think any effort should be spared.

SULAIMAN BIN ALI: It smells.

SUFYAN: One needs a liberty worthy of Basra's literary fame.

SULAIMAN BIN ALI: It is utterly unappealing.

SUFYAN: Calligrapher, damn you!

Exit SUFYAN.

SULAIMAN BIN ALI: Take your shirt off, young man. Too hot for shirts. Keep scrubbing.

Exit SULAIMAN.

Enter BASHAR IBN BURD, the blind poet, led by ABDULLAH IBN AL-MUQAFFA and WALIBA BIN HABBAB.

BASHAR: A nation of dogs! We gawp and nip at fleas as a new pack of wolves chases out the old pack of curs!

IBN AL-MUQAFFA: Shhh – we're in the Mirbid.

BASHAR: History's whorebed, this Mirbid!
 The murderer on horseback,
 And the penniless dead,
 Erect tongues and clenched fists
 frolicking all
 in dirty Mirbid's bloodstained bed.

IBN AL-MUQAFFA: Quiet!

BASHAR: This isn't the Mirbid – this is one of your tricks.

IBN AL-MUQAFFA: You would not believe me: here you are. It's the middle of the day.

BASHAR: Is it empty?

IBN AL-MUQAFFA: Pulsing, but there are ravens in every tree and under every stone: a spy.

BASHAR: Is this the network they spoke of? What did you call them?

IBN AL-MUQAFFA: Bareed, jackals, spies.

Re-enter SUFYAN.

SUFYAN: Persians, zindiqs* and heretics!

BASHAR: How do you know we are Persian, sir?

SUFYAN: You flaunt vulgar fashion even in mourning.

IBN AL-MUQAFFA: We are flattered, sir. Good day!

SUFYAN: God strike me dead if I ever complimented a Persian, you are soldiers good for slaughter and a tribe of insolent slaves.

BASHAR: Persia made you and Persia will devour you!

SUFYAN: What did he say?

IBN AL-MUQAFFA: We are scholars, sir, bookish men; don't be offended by our mumbling.

SUFYAN: Our prisons are humming with mumbling scholars.

IBN AL-MUQAFFA: Zindiq or heretic, sir, is not an insult in our language, rather it is a term of religious endearment.

SUFYAN: And you'll lecture me in religion, heretic!

BASHAR: Tell him he's the son of a whore.

SUFYAN: What did you say, Persian?

Enter SULAIMAN.

SULAIMAN BIN ALI: What's going on, Sufyan? Are these scribes?

IBN AL-MUQAFFA: We would not dare lecture you in religion, sir, one is merely preparing you to receive my friend's compliment in return.

SULAIMAN BIN ALI: Give us your compliment then scribes.

IBN AL-MUQAFFA: It is one reserved for Goddesses in Mazdak's* eyes.

SULAIMAN BIN ALI: Mazdak? We hear wonders of that madman. Tell us, then.

IBN AL-MUQAFFA: Your pledge first, noble sir.

SULAIMAN BIN ALI: On what?

IBN AL-MUQAFFA: That in return for knowledge, we may cross the Mirbid in peace.

SULAIMAN BIN ALI: If your words enlighten my mind, you will walk unmolested.

IBN AL-MUQAFFA: Our greetings then to Sufyan, son of The Mighty Promiscuous Mother!

SUFYAN: Son of an uncircumcised bitch!

SULAIMAN BIN ALI: (*Removing the knife from SUFYAN's hand.*) Where's the compliment in this?

IBN AL-MUQAFFA: In Mazdak's eyes.

SUFYAN: Manicheain* pig! Let me spill his blood, Sulaiman!

SULAIMAN BIN ALI: I'm trying to learn something, Sufyan, you might listen too! Speak, scholar.

IBN AL-MUQAFFA: Mazdak sees that women and money drive men to the greatest evil.

SULAIMAN BIN ALI: Go on.

IBN AL-MUQAFFA: Mazdak sees that if money and women were a common holding, a public property, one would thereby eliminate the sources of conflict between men.

SUFYAN: Heretic, enough!

IBN AL-MUQAFFA: God forgives all bar ignorance.

SUFYAN: I can't believe this!

SULAIMAN BIN ALI: On.

IBN AL-MUQAFFA: Promiscuity, then, is a divine attribute that opens in its opening harmony to all creation: your mother,

whore that she is Sufyan, is nothing less than a Goddess in Mazdak's eyes.

SULAIMAN BIN ALI: A compliment that masquerades as an insult, I like it.

IBN AL-MUQAFFA: May we cross the Mirbid now?

SULAIMAN BIN ALI: You may.

SUFYAN: Over this dead Arab body you Zoroastrian filth!

SULAIMAN BIN ALI: I! I am Governor of Basra: men of learning are safe under my rule. Go.

The three men cross the square, to the silent amazement of the onlookers. WALIBA kisses SULAIMAN's hand in fawning gratitude.

A young woman moves away from the crowd and follows them.

SUFYAN: I have never been so ashamed in all my life.

SULAIMAN BIN ALI: Ignorance is a cruel tax.

SUFYAN: Don't speak to me, Sulaiman, please do not even speak to me!

Enter ABDULLAH BIN ALI.

ABDULLAH BIN ALI: Shame on you, brother, drawing knives without inviting me, I love a little morning skirmish!

SUFYAN: (*To the SLAVE.*) Follow those Persian dogs and bring me news of who they are. Greetings, my Lord Abdullah.

SULAIMAN BIN ALI: Greetings, brother.

ABDULLAH BIN ALI: What time will the Calipha arrive?

SULAIMAN BIN ALI: Soon.

ABDULLAH BIN ALI: Is Abu Muslim going to do us the honour?

SULAIMAN BIN ALI: No. Retreated to Khurasan, we hear. Bathing in his dark glory.

ABDULLAH BIN ALI: Good. Then I will sit on the Calipha's right hand.

SULAIMAN BIN ALI: Why on his right hand?

ABDULLAH BIN ALI: Is Abdullah Bin Ali to be asked why?

SULAIMAN BIN ALI: Yes, why?

ABDULLAH BIN ALI: I am his uncle.

SULAIMAN BIN ALI: I too am the Calipha's uncle, I am his governor in Basra, but I don't ask to sit at his right hand. I know my place.

ABDULLAH BIN ALI: Did you tame Syria? Did you put down Egypt? Did you hound the Ummayids into the mouth of hell? I, Abdullah will sit on the Calipha's right hand in Basra.

SULAIMAN BIN ALI: Look, he specifically told me his brother is to sit on his right hand – here's the letter!

ABDULLAH BIN ALI: Al-Mansour?

SULAIMAN BIN ALI: Yes.

ABDULLAH BIN ALI: That gangling half-man? That sprog of barbarian loins!

SULAIMAN BIN ALI: The same.

ABDULLAH BIN ALI: I'm telling you now and before these witnesses I will not be seen on the same podium as Al-Mansour, I won't.

SULAIMAN BIN ALI: Try to be reasonable.

ABDULLAH BIN ALI: Yesterday we were seen begging in the streets and today we are the rulers of an empire. He has no beard.

SULAIMAN BIN ALI: He does have a beard, a thin one.

ABDULLAH BIN ALI: He was whipped in public!

SULAIMAN BIN ALI: No need to bring that up.

ABDULLAH BIN ALI: Scars on his back to prove it.

SULAIMAN BIN ALI: He is your nephew!

ABDULLAH BIN ALI: A shameful nephew! I'll tell the Calipha to his face.

SULAIMAN BIN ALI: You are putting me in an impossible position!

ABDULLAH BIN ALI: I won't discuss this further with you, arrange the seating as you wish, but I warn you: it's him or me! What entertainments have we here?

SULAIMAN BIN ALI: Sufyan, show my brother what you have prepared.

ABDULLAH BIN ALI: And fill my cup you sodomised minstrels!

SUFYAN: You can read it my Lord, across the square.

ABDULLAH BIN ALI: A...L...S...A...F –

SUFYAN: The Calipha's name, etched in dried Ummayid blood.

ABDULLAH BIN ALI: What kind of girl's libertina is this for the Calipha?

SUFYAN: We welcome your suggestions, General.

ABDULLAH BIN ALI: Line the square in stakes and chop off some heads to adorn them.

SULAIMAN BIN ALI: Abdullah, I'm trying to make the welcome party a civilised affair.

SUFYAN: Does my Lord think such a sight would please the Calipha?

ABDULLAH BIN ALI: It is not your job to please the Calipha, Sufyan, your job is to sow terror into the hearts of those that approach the Calipha. That will please the Calipha.

SUFYAN: How many do you think we would need, my Lord?

ABDULLAH BIN ALI: A baker's dozen?

SULAIMAN BIN ALI: They've not been tried yet!

ABDULLAH BIN ALI: Time has tried them all and proved them guilty. Line them up, Sufyan, put stakes around the square and I'll prune them before sunset.

SULAIMAN BIN ALI: I think I'll have a look at this God awful seating arrangement.

He exits.

SUFYAN: What if there are not exactly thirteen Ummayids in the prison?

ABDULLAH BIN ALI: Basra is a large town I think?

SUFYAN: It is, my Lord.

ABDULLAH BIN ALI: But is it larger than a man's imagination?

SUFYAN: Thank you.

SCENE 3

IBN AL-MUQAFFA's house. Enter IBN AL-MUQAFFA followed by ASIA, wearing a veil.

ASIA: Close the door, we are being followed.

IBN AL-MUQAFFA: I was: by you!

ASIA: Back door – do you have one?

IBN AL-MUQAFFA: What's this about?

ASIA: You were talking about Mazdak in the square.

IBN AL-MUQAFFA: I was – are you one of them?

ASIA: I was impressed by the courage you spoke with. You are Ibn Al-Muqaffa?

IBN AL-MUQAFFA: I am and you? Do I know your father?

ASIA: I have no father.

IBN AL-MUQAFFA: A name at all?

ASIA: Asia.

IBN AL-MUQAFFA: Asia! Who carries in her eyes all the splendours of Asia – what brings you to my door?

ASIA: Knowledge and need.

IBN AL-MUQAFFA: I see. Can I offer you some rosewater, Asia? Sorry, I'm not used to having young ladies in my house, I…

ASIA: We need you to stay alive.

IBN AL-MUQAFFA: Excellent, we've got lots in common already!

ASIA: The way you're acting, you'll be dead in three days.

IBN AL-MUQAFFA: How very dramatic! Who's 'we', may I know?

ASIA: The soothsayer's crows flap madly into the night,
Women, from Kufa to Kandahar, wake up widowed in their beds
and across the lands of Islam, men turn to the sun
their faces covered in ash!

IBN AL-MUQAFFA: Is that code? Or just propaganda?

ASIA: There are many of us.

IBN AL-MUQAFFA: Alawis, Rawandians, Zoroastrians, Mazdakians?[1] There are so many sects these days one loses count.

ASIA: We're not a sect. We're Muslim thinkers.

IBN AL-MUQAFFA: I am not a Muslim.

ASIA: But you are a thinker.

IBN AL-MUQAFFA: My principles are my own, I don't share them with organisations.

ASIA: Islam is not an organisation: it is a divine system of social justice.

IBN AL-MUQAFFA: Yes! That aspect is most arresting but, equally, that's the very aspect that demands most interpretation – I've written about this in…

ASIA: The revolution is outside your door! Two lions in a pit: take sides or be gored. (*Pause.*) Why are you laughing?

IBN AL-MUQAFFA: Asia, oh God, Asia! Did ever a woman's name pronounce her beauty so well?

ASIA: Don't condescend to me –

IBN AL-MUQAFFA: Or her intelligence!

ASIA: Rawzabah!

1. Or, for fun: 'Zarqawis, Nationalists, Baathists, Islamists'

22

IBN AL-MUQAFFA: Sorry, I'm so sorry. It's violence – it terrifies me. I think I'd be an utterly useless revolutionary.

ASIA: Then you'll die at the hands of an utterly ruthless one.

IBN AL-MUQAFFA: Are you here to threaten me?

ASIA: It's your pen that threatens you, Ibn Al-Muqaffa!

IBN AL-MUQAFFA: My pen?

ASIA: Yes, your pen is the sword at your throat.

IBN AL-MUQAFFA: I sharpen my nib daily, but really a sword is pushing it –

ASIA: You write on Kings –

IBN AL-MUQAFFA: Persian Kings, long dead, inoffensive to the modern mind –

ASIA: You write on modes of ruling –

IBN AL-MUQAFFA: Sasannian court practices, mummified texts –

ASIA: You write on morals –

IBN AL-MUQAFFA: Indian wisdom. Undisputed pearls of moral pedagogy, light exotica, very neutral, no danger there. What else?

ASIA: They say you have a project with Arabic prose –

IBN AL-MUQAFFA: I do –

ASIA: To rival the beauty of the Koran!

IBN AL-MUQAFFA: That is vicious slander! Bloodthirsty, illiterate lie – I will not allow it!

ASIA: It's what they say! Not the illiterate, the elite. We have the same enemies, Rawzaba. Those that manipulate knowledge to promote ignorance, are the same men that take the Holy Books and use them to brain the unborn child, they are the same that take the sword to thousands in cold blood and raise the banner of 'God's Will' – it is not God's will.

IBN AL-MUQAFFA: Let me tell you about Jur. Jur is where roses are from. I am not the most handsome of men but I…am not bereft of marks that turn womens' eyes. The shadow of my pen crosses lips from Isfahan to Palestine and from the

flow of its ink I am showered with fine clothes, wide lands and bird-filled orchards. But without a wife, my nights are ...full of dust: Asia, I want to return to Jur, where roses are from and perhaps you might, I mean, you would maybe, you could, I mean maybe –

ASIA: Sshh!

The sound of a knife scratching against wood.

They are marking your door.

IBN AL-MUQAFFA: Who is?

ASIA: Sufyan. They tag their prey and return in an hour.

IBN AL-MUQAFFA: I'll leave now. Will you come with me?

ASIA: What are you asking me, Rawzaba?

IBN AL-MUQAFFA: Will you be my wife?

ASIA: No.

IBN AL-MUQAFFA: Why not?

ASIA: You are not needed in Jur, you would be flaccid, futile and useless in Jur! You are needed in Basra: only in Basra would I love you.

IBN AL-MUQAFFA: I'd taste death to taste your love: but Rawzaba dead has no love to give.

ASIA: I have arranged an audience for you with the new Calipha, Al-Saffah.

IBN AL-MUQAFFA: What?!

ASIA: You will meet him tonight, impress him, and take a position in the Abbasid court.

IBN AL-MUQAFFA: Three things are perilous: entrusting yourself to a woman, and befriending kings.

ASIA: What's the third?

IBN AL-MUQAFFA: Testing poison for strength.

ASIA: Come to the Mirbid after the evening prayers.

IBN AL-MUQAFFA: How will I approach his tent?

ASIA: Are you so wide in learning and narrow in strategy, Rawzabah?

IBN AL-MUQAFFA: No, I... I've read Homer's Iliad!

ASIA: When you arrive, look for me; read my signs.

IBN AL-MUQAFFA: Just tell me what kind of man is the Calipha?

ASIA: Don't play to his intellect, he'll get bored, offended and throw you out.

IBN AL-MUQAFFA: How should I approach him then?

ASIA: Like a child.

She exits.

IBN AL-MUQAFFA: Abrash! Help me pick up this wretched carpet!

SCENE 4

Inside the Calipha's tent.

ABU AYYOUB, SUFYAN and RABIH.

SUFYAN: So, on the Calipha's right we have this place reserved for Abu Muslim.

ABU AYYOUB: He's not coming.

SUFYAN: That's fine, his place needs to be marked. Then we have his brother Al-Mansour and here the uncle, Abdullah. Now the question is should we place another three empty ones on his left, for symmetry, or just scrap the left flank altogether?

ABU AYYOUB: Both are monstrous. The Calipha will have men neither on his left nor on his right: He will not be approached. And those that do approach him, do so alone and from a distance.

SUFYAN: Is this new, Abu Ayyoub?

ABU AYYOUB: It is the Sasannian practice and has been adopted by the Calipha. Anything less is high treason.

SUFYAN: (*To RABIH.*) Get rid of these, out! Even Abu Muslim's?

ABU AYYOUB: All of them.

SUFYAN: Let's hope he doesn't make a surprise entrance, then.

Enter AL-MANSOUR, ABDULLAH BIN ALI, his daughter ASIA, SULAIMAN BIN ALI, councillors, guests, servants.

ABDULLAH BIN ALI: Propaganda? You want propaganda?

AL-MANSOUR: We're listening, Uncle.

ABDULLAH BIN ALI: Stretch the flayed skin of an Ummayid over a drum.

SULAIMAN BIN ALI: Marvellous! A drum of human skin.

ABDULLAH BIN ALI: The sound of it would thump your name through the backstreets of every village for a thousand miles.

SULAIMAN BIN ALI: That's banging the drum for you!

ABDULLAH BIN ALI: I had the best drum-maker in Damascus try it, but it seems these stinking hides of ours are too thick!

AL-MANSOUR: I think you'll find that a run of ten thousand small gold coins carrying our insignia would be a far more effective tool of power. To rule effectively, one must –

ABDULLAH BIN ALI: Kill!

AL-MANSOUR: Share the burden of killing.

ABDULLAH BIN ALI: The more throats that are slit the better.

AL-MANSOUR: More throats are slit over coins than your armies could ever mow down.

ABDULLAH BIN ALI: You've clearly never seen an army. Bring wine you sodomised goats, am I expected to fight the Roums* sober?!

ASIA: Tell me Uncle, who is chamberlain to the Commander of the Faithful?

SULAIMAN BIN ALI: The terrible black one.

ASIA: Does he choose the poets that are presented to the Calipha tonight?

SULAIMAN BIN ALI: Yes, he's a poet himself.

ASIA: Is he good, Uncle?

SULAIMAN BIN ALI: Viciously good.

ASIA: Would you introduce me?

SULAIMAN BIN ALI: Is that a glint I see in your eye, girl?

AL-MANSOUR: Peace is far harder to tame than war.

ABDULLAH BIN ALI: And which yellow-blooded monkey wants to tame war?

AL-MANSOUR: There is a limit to the effectiveness of war.

ABDULLAH BIN ALI: Not in the next ten years there isn't.

AL-MANSOUR: One has to start thinking about what happens after wars. The Calipha is of this opinion too.

ABDULLAH BIN ALI: That you know better than any woman how to hide through wars, I'll grant you. The Calipha knows this also.

SULAIMAN BIN ALI: You've gone too far.

ABDULLAH BIN ALI: What, nephew, are you winded?

ABU AYYOUB: The Calipha's brother has lost the desire to grace your Excellency with his voice.

ABDULLAH BIN ALI: Who is this newt ventriloquist?

SULAIMAN BIN ALI: Abu Ayyoub, a councillor, versed in Sasannian manners of court.

ABU AYYOUB: But he is happy to continue to converse with you, indirectly in the manner of Sasannian kings, through the intermediary of his chosen spokesman: myself.

ABDULLAH BIN ALI: And another bastard fetish slinks into the mighty Muslim court!

ABU AYYOUB: It is a form of dialogue called the prism. It takes the irrational heat out of words and prevents the knife of sedition from afflicting the family body.

ABDULLAH BIN ALI: Speak, then.

ABU AYYOUB: The Calipha's brother feels your Excellency is all rage and bluster, empty as your beloved drum.

SULAIMAN BIN ALI: Do you want me to find you a councillor?

ABDULLAH BIN ALI: Tell my mute nephew that I think he has pissed himself and is using you to prevent anybody from noticing.

ABU AYYOUB: I can assure your Excellency, there's not a man in this tent who can piss anywhere in Iraq without my Lord receiving a full report on the arc, stream and colour of his urine –

ABDULLAH BIN ALI: Ah! Men of Iraq! Hide your organs! The Calipha's brother has eyes for them!

Laughter.

SULAIMAN BIN ALI: Please, Abdullah, not in the tent!

Enter RABIH.

RABIH: Commander of the Legions of the Faithful, Descendant of the Blessed House of Muhammed, Imam of the Eternal Revolution, He that was prophesied in the seeing books and the yellow parchment, the Chosen of the Al-Abbas, Vice-regent of God,

SULAIMAN BIN ALI: 'Vice-regent of God', that's new –

ASIA: It's disgusting!

RABIH: Ruler of Sind, Tabaristan, Yemen, Mecca, the lands of Alexander, the lands of Darius, Damascus, Ray, Khurasan, Palestine, Egypt, the lands of Iraq and Persia – Calipha Al-Saffah.

Enter the Calipha, AL-SAFFAH.

AL-SAFFAH: It is so very…lonely up here.

AL-MANSOUR: Is God alone, my Lord?

AL-SAFFAH: God is well practised, brother.

SULAIMAN BIN ALI: Did the Calipha's eye not delight in the decorations on the edge of the square?

AL-SAFFAH: Bored of heads!

SUFYAN: Your name in Kufic red across the Mirbid, my Lord?

AL-SAFFAH: Bored of blood. Ow!

AL-MANSOUR: Do you suffer, my Lord?

AL-SAFFAH: This crown is murdering my neck.

ABDULLAH BIN ALI: Would my Lord like me to hold it for you?

AL-SAFFAH: Oh Uncle, you'd dangle the beast on your little finger.

AL-MANSOUR: I'll hold your crown for you brother, and with both hands.

AL-SAFFAH: Abdullah?

Simultaneously:

AL-MANSOUR: } { Yes!
ABDULLAH BIN ALI: } { Yes!

AL-SAFFAH: This so reminds me of a dream I had. It's uncanny.

ABDULLAH BIN ALI: A dream, my Lord?

AL-SAFFAH: Come forwards both of you. Walk towards me in silence, let me see you.

ABDULLAH BIN ALI and AL-MANSOUR walk towards AL-SAFFAH.

As they approach him, ABDULLAH BIN ALI trips AL-MANSOUR.

AL-MANSOUR falls.

AL-MANSOUR: Son of an uncircumcised whore!

ABDULLAH BIN ALI: He's too scrawny!

AL-MANSOUR: Brother, give me his blood –

ABDULLAH BIN ALI: His legs can't carry him to the seat of the Calipha!

ABU AYYOUB: My Lord, I beg you look to this!

AL-SAFFAH: I can't remember if this happened in my dream or not!

ASIA lunges forward.

Is that our cousin?

ABDULLAH BIN ALI: When the moon is full my daughter has visions, my Lord.

AL-SAFFAH: Does she indeed?

ABDULLAH BIN ALI: I have won battles through her visions.

AL-SAFFAH: How fun.

ASIA: (*Singing.*)
Oh slaves in the wheat fields of day
Now to the night harvester come pay
The difference between the value of the hide and the value of
 the wine,
Men are wind-grown, men are wind-blown
Beneath the chaff of words
lie grains the moon has sewn,
The animals are coming!
The animals are coming!
Give them tongue: let them come,
Give them tongue: let them come!

ASIA collapses into her father's arms and is carried off.

Enter IBN AL-MUQAFFA.

IBN AL-MUQAFFA: I am a scribe who claims he has uses to the Calipha.

SUFYAN: My Lord, I know this man.

AL-SAFFAH: Is this?

IBN AL-MUQAFFA: Ibn Al-Muqaffa, my Lord.

AL-SAFFAH: Yes, they said you were coming. We are honoured to entertain such an illustrious scribe.

SUFYAN: His pen danced for the Ummayids like a whore.

AL-MANSOUR: So did your sword, Sufyan.

IBN AL-MUQAFFA: It is not a sin to have had one's talents appreciated by men of power and taste, even if history deems those men invalid.

SUFYAN: This man's existence is an insult to the glorious revolution.

IBN AL-MUQAFFA: It has always been one of the curses of Iraq that power is seized by its savages. My Lord, if you would avoid re-uttering that curse with your own lips then do not give power to men such as these.

AL-SAFFAH: What's your business with us, scribe?

IBN AL-MUQAFFA: I have a liberty, if the Calipha will allow. A carpet, my Lord, with which you can salary a hundred scribes for a hundred years.

AL-MANSOUR: A fine addition to any treasury. What's this book inside the carpet?

IBN AL-MUQAFFA: A book of counsel I am translating.

AL-MANSOUR: From the Persian?

IBN AL-MUQAFFA: Indian.

ABU AYYOUB: Kalila wa Dimna?

IBN AL-MUQAFFA: That's it!

AL-MANSOUR: The Mirror For Princes?

IBN AL-MUQAFFA: Exactly.

ABU AYYOUB: It has shamanic origins.

IBN AL-MUQAFFA: It's not complete yet, but I hope that with the Calipha's blessing –

SUFYAN: He mocks us like children!

IBN AL-MUQAFFA: Kings will take from its wisdom and idiots will laugh at its jests. Some will see in it the mere puppetry of animals, others glean through it the machinery of kings: I dedicate it to the Commander of the Faithful.

AL-SAFFAH: How does it work?

IBN AL-MUQAFFA: It is a book; one has to read it, my Lord.

AL-SAFFAH: What for? Show me how it works.

IBN AL-MUQAFFA: Allow me to demonstrate.

SUFYAN: This court is being raped!

IBN AL-MUQAFFA begins to read from the book, as the JACKAL captures the attention of the court with a perverse animal puppet show.

AL-MANSOUR: What's going on?

SUFYAN: Rabih, swords!

AL-SAFFAH: Shh!

DIMNA: Dimna the Jackal trembles to greet the King and his court.

AL-SAFFAH: His court; of course! (*In hysterics.*) My court! Genius!

ABU AYYOUB: My Lord, I fear there is insult in this bestiary –

AL-SAFFAH: Not a word, Abu Ayyoub! This is genius.

DIMNA: Yes, my Lord, beware such imposters in your court.

AL-SAFFAH: Imposters! Beautiful!

DIMNA: My Lord, the best of words are short and clear.

PIG: Don't mix honey with poison, jackal, spit it out!

DIMNA: Then I'll be brief: I long to be closer to your majesty.

PIG: Away with your lice!

DIMNA: I have hidden attributes and some knowledge that may be of value to you.

PIG: Hidden attributes, aye, well hidden indeed: you stink from here to Kufa, are cross-eyed and have a snout made for poor men's bins!

IBN AL-MUQAFFA: If you listen carefully, my Lord, you'll catch the resemblance between the pig and a man in this tent.

PIG: My Lord, the court is being raped!

AL-SAFFAH: Oh, look it's meant to be Sufyan! That's brilliant!

SUFYAN: My Lord, I'm mortally offended.

AL-SAFFAH: So would I be if I had a face like this pig's!

Animals fall about with laughter.

Exit SUFYAN.

PIG: I shall not be made to weep.

IBN AL-MUQAFFA: Enough! My Lord, it is not my aim to offend, but rather to entertain in a manner that –

AL-MANSOUR: We understand your entertainment and are partial to it.

Re-enter SUFYAN.

SUFYAN: My Lord, I too have a liberty for you.

AL-SAFFAH: I hope it's better than your last one, Sufyan.

SUFYAN: A full stop at the bottom of the Ummayid page.

SUFYAN reveals the head of ABDUL HAMEED.

IBN AL-MUQAFFA: Abdul Hameed!

SUFYAN: A friend of yours I believe?

AL-SAFFAH: How perfectly revolting! Take some gold for that.

The animals have started to weep.

Weeping animals! Too much! Basra swells with the keening of animals, ha, ha! Give that scribe gold, bags of it: let him follow us, we'll keep him.

Exit AL-SAFFAH and others.

ASIA: I love you.

IBN AL-MUQAFFA: I've entered a ring of fire.

ASIA: Kiss me.

IBN AL-MUQAFFA: Please don't touch me: I feel sick.

ASIA: You are growing, I believe.

IBN AL-MUQAFFA: In every direction,
stars in God's Engine
run on
blindly.

She kisses him.

ABU AYYOUB enters and watches, unseen.

End of Act One.

ACT TWO

SCENE 1

IBN AL-MUQAFFA; BASHAR; WALIBA in a Persian drinking den.

WALIBA: And then?

IBN AL-MUQAFFA: Then he ordered them to give me gold and later I was asked to follow them back to Al-Anbar*.

WALIBA: Will you go?

IBN AL-MUQAFFA: Haven't decided.

WALIBA: Why not?

BASHAR: After what happened to Abdul Hameed?

WALIBA: Abdul Hameed made the mistake of becoming a symbol of power, it was inevitable.

IBN AL-MUQAFFA: Nothing is inevitable! Abdul Hameed was the victim of a bloodthirsty maniac and if there is one good reason for me to go it is precisely to stop maniacs like that from gaining power.

BASHAR: They're trying to ban wine, haven't you heard?

WALIBA: Ha! Good luck to them.

IBN AL-MUQAFFA: Islam is a great religion, if what they are claiming is true – equality for all believers Persian or Arab – it may be that it can also become a great empire.

WALIBA: I'm working on a dedication, if you do go would you get me an audience?

IBN AL-MUQAFFA: Of course.

BASHAR: And what will you do there?

IBN AL-MUQAFFA: Carry on with the animal tales and write what I'm asked for.

WALIBA: They need writers at the rate the empire's expanding.

BASHAR: And at the rate they're killing them off. You'll turn into a bureaucrat with a pinched smile, start losing your hair, next you know, you'll be informing on your friends.

IBN AL-MUQAFFA: I take objection to that!

BASHAR: What will you be then – the court jester, the satirist?

IBN AL-MUQAFFA: The tales are not court entertainment.

BASHAR: Fooled me.

IBN AL-MUQAFFA: Through them I am formulating a critique.

BASHAR: Through a picaresque about two jackals.

IBN AL-MUQAFFA: Through the style I'm writing in.

BASHAR: Oh, brave critique that leaves content at the door and challenges with style. And which of our plagues does your stylish critique pretend to remedy?

WALIBA: The plague of power?

IBN AL-MUQAFFA: Exactly, Waliba.

BASHAR: And since when has critique ever toppled dynasties, or stopped the sword short of a writer's head? Tell me that, ha?

Silence.

Good, I win. Waliba, go and fetch me two jugs of wine on Ibn Al-Muqaffa's account.

Exit WALIBA.

IBN AL-MUQAFFA: I'll miss you, if I do go.

BASHAR: Won't keep me away for long, I've a new ode to the female jewel, wasted on the local girls their ears are too coarse for it, needs a Cassandra, a court kitten rubbed in rose oil.

Enter WALIBA.

WALIBA: Someone's asking for you.

IBN AL-MUQAFFA: Who is it?

WALIBA: Don't know, she wouldn't say.

BASHAR: A woman?! And you let her stand outside – eunuch!

WALIBA: Is there not a civil word in your head?

BASHAR: My head is a most upright civilian.

IBN AL-MUQAFFA: To which every whore in Basra will swear with her eyes closed!

BASHAR: Your cup, zindiq! Pour the wine, Waliba, let me teach you some poetry –

Outside.

ASIA: Do you think I'm a fool?

IBN AL-MUQAFFA: Asia, what is it?

ASIA: I was wrong to trust you, you're an opportunist and a hack!

IBN AL-MUQAFFA: Tell me what's happened?

ASIA: I take my reputation and my life in my hands and this is how you repay me?

IBN AL-MUQAFFA: Repay you how! What's happened?

ASIA: Use me like a pawn to feed your dirty ambitions, go to my father behind my back –

IBN AL-MUQAFFA: I haven't even met your father.

ASIA: Said he'd sooner kill me than have me marry a non-Muslim –

IBN AL-MUQAFFA: What's this about?

ASIA: Another mask! I can't believe it!

IBN AL-MUQAFFA: Who wants to marry you?!

ASIA: You!

IBN AL-MUQAFFA: In every eye a knife.

ASIA: What?

IBN AL-MUQAFFA: Someone saw us talking and told him.

ASIA: You didn't go to him?

IBN AL-MUQAFFA: Of course not! Asia: I love you.

ASIA: Stop it, please.

IBN AL-MUQAFFA: Let me look at you.

ASIA: No. Let go. We're going to Damascus tomorrow. I don't know when I'll see you again.

IBN AL-MUQAFFA: Why? Damascus, why?

ASIA: War. More war.

IBN AL-MUQAFFA: And you're an archer, a lancer, a –

ASIA: My father needs me, sometimes I see the future – what are you doing?

IBN AL-MUQAFFA: Come on.

ASIA: Where are you taking me?

IBN AL-MUQAFFA: I thought you could see into the future.

ASIA: No. Don't be insane! He'll kill us.

IBN AL-MUQAFFA: This way? Or that way?

SCENE 2

ABDULLAH BIN ALI: I have listened to you most carefully, Sharzaba –

IBN AL-MUQAFFA: Rawzabah, my Lord.

ABDULLAH BIN ALI: Rawzabah, Sharzaba, it's all Persian isn't it?!

IBN AL-MUQAFFA: Quite.

ABDULLAH BIN ALI: As I say, listened most intently; your reasons for addressing my daughter in public last night are now clear to me, you are able to quote more Koran to my face than any theologian I know but one question remains unanswered in my mind.

IBN AL-MUQAFFA: Which is?

ABDULLAH BIN ALI: When the mosques are spilling over with ranters looking for converts, why have you chosen to come to me?

IBN AL-MUQAFFA: You force me to speak of that which I would rather not speak.

ABDULLAH BIN ALI: Which is?

IBN AL-MUQAFFA: Myself.

ABDULLAH BIN ALI: Be my guest.

IBN AL-MUQAFFA: My name is Ibn Al-Muqaffa: I am the son of the man with the shrivelled hand.

ABDULLAH BIN ALI: Ibn Al-Muqaffa?!

IBN AL-MUQAFFA: Rawzabah, my Lord.

ABDULLAH BIN ALI: Sharzaba!

IBN AL-MUQAFFA: Yes. My father was a collector of state taxes who brought to his occupation such zeal and diligence as was fuelled by what I can only call a hunger for justice amongst men.

ABDULLAH BIN ALI: Speaking of hunger, I'm famished – boy!

IBN AL-MUQAFFA: This hunger, my Lord, succeeded in attracting the enmity of the landowners in our province –

ABDULLAH BIN ALI: Boy!

IBN AL-MUQAFFA: And they, to better ward their wealth, sought his downfall –

One spring morning, whilst ice cracked on the lakes, I watched as my father's hand was laid on a slab of stone and thrashed with a mallet until it was pulped.

ABDULLAH BIN ALI: Punished for stealing?

IBN AL-MUQAFFA: He had not stolen: but one of the landowners was a friend of the Calipha's cousin.

ABDULLAH BIN ALI: A-ha! Now the boy is a man he wants to wrap a little finger round that mallet of power!

IBN AL-MUQAFFA: If there are any meagre virtues to be had amongst men from converting Ibn Al-Muqaffa to Islam, there are none more worthy to receive them than you: Abdullah.

ABDULLAH BIN ALI: You have spoken well and tomorrow you too will be a muslim that carries my name: Abdullah!

IBN AL-MUQAFFA: Nothing is more soothing to my soul.

ABDULLAH BIN ALI: Bring food! Bring wine, you little goat! You're going to Al-Anbar with the Calipha?

IBN AL-MUQAFFA: That is his desire. I should be happier to travel with you to Damascus my Lord, I may be of service to you there and I –

ABDULLAH BIN ALI: Nothing of the sort! You'll be of more service to me in the Calipha's court, you'll be my man there.

IBN AL-MUQAFFA: Your man, my Lord?

ABDULLAH BIN ALI: Inside.

IBN AL-MUQAFFA: I'm not sure I follow you.

ABDULLAH BIN ALI: You're a clever man and a good writer, these qualities must be used to your advantage or you'll be aubergined.

IBN AL-MUQAFFA: Aubergined?

ABDULLAH BIN ALI: Cut up into little slivers and fried. Aubergined.

IBN AL-MUQAFFA: My Lord, I'm not sure my skills are best adapted to that kind of work, it's –

ABDULLAH BIN ALI: Wielding power at court is like walking in single file –

IBN AL-MUQAFFA: That may be, but –

ABDULLAH BIN ALI: Unless you have spies at either end of the file, it is a life threatening formation.

IBN AL-MUQAFFA: My Lord, I'll be frank with you. I would rather come with you to Damascus and prove myself to you in other ways.

ABDULLAH BIN ALI: Why?

IBN AL-MUQAFFA: I want to ask you for your daughter, Asia's, hand in marriage.

Pause.

ABDULLAH BIN ALI: Are you insane?

IBN AL-MUQAFFA: Perhaps. If my request offends you, I'll withdraw it.

ABDULLAH BIN ALI: Luckily my sober sensibility is entirely modern, had you caught me drunk I'd have probably killed you.

IBN AL-MUQAFFA: How very fortunate.

ABDULLAH BIN ALI: A little man fed on high hopes can achieve greater things than a pack of slovenly whelps born to greatness.

IBN AL-MUQAFFA: That's true, my Lord.

ABDULLAH BIN ALI: You'll write me daily reports on all that's of note in the court, paying particular attention to the dealings of that eel, my nephew, Al-Mansour. Prove your worth to me and we'll talk when I return from Damascus.

IBN AL-MUQAFFA: Not a shrub will be planted, not a translation commissioned without you knowing about it.

ABDULLAH BIN ALI: Not interested in shrubs or translations. Eat now, and tomorrow you are Abdullah.

IBN AL-MUQAFFA: (*Muttering a Manichaean prayer.*)

ABDULLAH BIN ALI: Still mumbling your fire worship?

IBN AL-MUQAFFA: I cannot bear to eat without a God.

SCENE 3

Night in the palace.

RABIH: The Calipha?

ABU AYYOUB: Worse by the hour.

RABIH: Word has spread, the town is emptying.

ABU AYYOUB: I want you to go into town and burn the house of every physician that's been here in the last three days and even the houses of those that haven't.

RABIH: What rumour to fan the flames?

ABU AYYOUB: Say that the physicians of this town are the fabricators of seditious reports about the Calipha's ill-health.

RABIH: And?

ABU AYYOUB: That enemies of the state should not imagine that because it is the Holy Season of Hajj or because all the leading men of the family are away that the palace will tolerate such malicious tongues.

RABIH: Anything else?

ABU AYYOUB: That the Calipha himself will preach on this very subject at the Friday prayers.

RABIH: Is it the pox?

ABU AYYOUB: He'll be dead before dawn.

RABIH: The successor?

ABU AYYOUB: The parchment is by his bed, he's yet to write the name.

RABIH: It has to be written.

ABU AYYOUB: His hand is too weak to pick up the feather.

RABIH: Abdullah in Syria, Abu Muslim and Al-Mansour are three days away.

ABU AYYOUB: His hand is so weak.

RABIH: Surgery begins with razors, but when physic fails, all ends with swords.

ABU AYYOUB: What if I had to hold the pen for him, or guide it as it scrolls?

RABIH: I'll burn the rumours.

SCENE 4

ABU AYYOUB: Al-Mansour has made it very clear he wants colour-coding for the staff: scribes in yellow, tax collectors blue, police brown and judges black, the only ones exempt from this system are the informers who should wear commoners clothes.

IBN AL-MUQAFFA: Why is it whenever I enter a room, someone scuttles out of it?

ABU AYYOUB: You're a popular man, Ibn Al-Muqaffa, and now that you're a Muslim –

IBN AL-MUQAFFA: Don't lie to me, Abu Ayyoub, I know when I'm being spied on.

ABU AYYOUB: What do you expect? Power is, as we are now learning, a function of –

IBN AL-MUQAFFA: A function of information, yes, yes I've heard that.

ABU AYYOUB: If you would let me finish. What I was going to say was that now you are a Muslim, you must expect your enemies to increase in manifold numbers.

IBN AL-MUQAFFA: I don't see why.

ABU AYYOUB: You're that much closer to power.

IBN AL-MUQAFFA: I'm not interested in any position.

ABU AYYOUB: Regardless. Others are.

IBN AL-MUQAFFA: Legions, I've seen them, each one more illiterate and filthy than the last. The doorman, the doorman I say, puts it about that he knows two verses of the Koran and suddenly he's religion's keeper!

The sound of thousands of men exhaling in unison during prayer. IBN AL-MUQAFFA looks through a small aperture in the wall.

ABU AYYOUB: Abu Muslim and his army.

Again the sound.

IBN AL-MUQAFFA: What moves these men, Abu Ayyoub, is it God? Or not knowing how to write their own names? What is it exactly churns this heaving sea of men?

ABU AYYOUB: On the topic of theology, I've heard it said that you are well versed in Islamic texts?

IBN AL-MUQAFFA: I know the Koran by heart.

ABU AYYOUB: All of it?

IBN AL-MUQAFFA: My conversion wasn't born of the instant.

ABU AYYOUB: Canonical law?

IBN AL-MUQAFFA: Absolutely. Life of the Prophet, exegesis.

ABU AYYOUB: Interesting.

IBN AL-MUQAFFA: Now look, I have not been able to do anything with Al-Saffah's elegy –

ABU AYYOUB: Oh, dear. I'll have to inform the Calipha.

IBN AL-MUQAFFA: Tell him I've got a better man lined up for it.

ABU AYYOUB: Who's that?

IBN AL-MUQAFFA: Waliba.

ABU AYYOUB: Bin Habbab?

IBN AL-MUQAFFA: Waliba is an excellent poet and the Calipha will thank me for him. He's on his way up from Basra now.

ABU AYYOUB: Another zindiq crawls on to the list of your acquaintances.

IBN AL-MUQAFFA: What list?

ABU AYYOUB: I'm speaking to you as a fellow scribe; there's a lot of talk about your acquaintances.

IBN AL-MUQAFFA: What kind of talk?

ABU AYYOUB: The bottle's been shaken, my friend. All that was settled has been thrown up in the air.

IBN AL-MUQAFFA: Which bottle? The wine bottle? The bottle at the bottom of the Tigris that contains all our fates curled on little tags? Will nobody talk straight in this palace!

ABU AYYOUB: Keep your voice down. It's no secret to anybody your affection for Abdullah.

IBN AL-MUQAFFA: Affection is hardly apt. He has my gratitude for opening the doors of the faith to me and I don't see how he could be on any list of dubious acquaintances – he's only Al-Mansour's Uncle!

ABU AYYOUB: Your namesake claims the throne for himself.

IBN AL-MUQAFFA: What?!

ABU AYYOUB: Abdullah has risen in Syria.

IBN AL-MUQAFFA: Has he?

ABU AYYOUB: And I'll tell you another thing: unless you can show Al-Mansour exactly where your loyalties lie, making it clear as rock crystal, you'll be bedding down in the dungeon within a week.

Enter RABIH with WALIBA BIN HABBAB.

RABIH: There he is.

WALIBA: Ibn Al-Muqaffa!

IBN AL-MUQAFFA: Waliba, my friend, you've brought the sun in with you.

Exit ABU AYYOUB.

WALIBA: Like Jonah in the belly of a whale!

IBN AL-MUQAFFA: All the windows have been closed for the mourning. (*To RABIH.*) Leave it open for a few minutes, man

RABIH: If anyone sees.

IBN AL-MUQAFFA: I'm responsible. Have you prepared the poem?

WALIBA: It fizzled and burped its way along on the back of my horse maturing from eulogy to elegy like grapes into wine.

IBN AL-MUQAFFA: Cut the boozy similes, please, you're in Al-Mansour's palace now.

WALIBA: Milk to cream, then.

IBN AL-MUQAFFA: Butter!

They laugh.

RABIH: Oh yes, the Calipha's asked for you.

IBN AL-MUQAFFA: When?

RABIH: Now.

IBN AL-MUQAFFA: Why didn't you tell me straight away, you fool!

RABIH: I did!

IBN AL-MUQAFFA: Who told you?

RABIH: Abu Ayyoub told me to tell you.

IBN AL-MUQAFFA: But he was just here a minute ago!

RABIH shrugs.

What else have you forgotten to tell me?

RABIH: The maids are whispering.

IBN AL-MUQAFFA: Whispering what?

RABIH: Abu Muslim,
Abu Muslim
Abu Muslim.

IBN AL-MUQAFFA: Shut up! Close the window.

WALIBA: The Revolution's murdering minister.

RABIH: They say he kills like other people blink.

IBN AL-MUQAFFA: Take Mister Waliba to the house and stop parroting what maids say in public, my most esteemed doorman.

WALIBA: You'll find me safely ensconced in the cellar or somewhere.

IBN AL-MUQAFFA: Just keep your hands off the cook, her husband's a maniac.

WALIBA: What do you think I am? A boor like Bashar?

Exit.

SCENE 5

AL-MANSOUR, ABU AYYOUB, SUFYAN.

Enter IBN AL-MUQAFFA.

ABU AYYOUB: Here's the man himself, ask him directly.

SUFYAN: I'm telling you I have proof!

ABU AYYOUB: (*To IBN AL-MUQAFFA.*) Ignore Sufyan.

SUFYAN: My Lord, I have tried to warn you.

IBN AL-MUQAFFA: What's he ranting about?

ABU AYYOUB: Says you are Abdullah's spy, claims he can prove it.

IBN AL-MUQAFFA: (*To SUFYAN.*) How are you both, Sufyan?

SUFYAN: Who are we 'both'?

IBN AL-MUQAFFA: You and your nose of course. It would be immeasurably rude of me to greet one and ignore the other.

SUFYAN: It's intolerable! Will nobody put this scribbler in his place?!

RABIH: My Lord, Abu Muslim is outside.

ABU AYYOUB: (*To IBN AL-MUQAFFA.*) There's something I have to tell you about Abu Muslim.

IBN AL-MUQAFFA: Yes?

ABU AYYOUB: He is one of the most terrifying men on earth, but if you can sugar your tongue with piety, he becomes meek as a lamb.

IBN AL-MUQAFFA: Why do I need to know that?

Enter RABIH and ABU MUSLIM.

RABIH: (*Introducing ABU MUSLIM.*) The High Commander of the Revolution, Minister of the House of Muhammed, Governor of Khu –

AL-MANSOUR who has been crouched on the ground and poking the earth with a stick, interrupts RABIH with a gesture.

AL-MANSOUR: Do you have nothing to say to me Abu Muslim?

ABU MUSLIM: My condolences.

AL-MANSOUR: I think you have not congratulated me on the Caliphate.

ABU MUSLIM: My apologies.

AL-MANSOUR: Your silence in this matter causes us pain.

ABU MUSLIM: That grieves me.

AL-MANSOUR: Will you do nothing but bleat apologies like a sheep at slaughter!

ABU MUSLIM: Thirty thousand men – outside your door thirty thousand men –

AL-MANSOUR: My troops! Under your command.

ABU MUSLIM: Sixty thousand eyes nesting on your door, looking with love towards you. I opened their hearts and placed the tribe of Banu Hashem inside them, I bound them in obedience to the line of Muhammed, I make firm your sovereignty, I made you known where you were once ignored and I make you loved where otherwise you are despised.

AL-MANSOUR: Is this a debt you're claiming?

ABU MUSLIM: A debt like this can't be paid in this world.

AL-MANSOUR: What are you describing then?

ABU MUSLIM: My bond of love to the House of Muhammed.

AL-MANSOUR: There are many men in the House of Muhammed.

ABU MUSLIM: All good men.

AL-MANSOUR: Who do you love?

ABU MUSLIM: You must forgive me, I must to Khurasan.

Pause.

AL-MANSOUR: My uncle – Abdullah – rises against us in Syria, claiming the caliphate for himself.

ABU AYYOUB: You see how the devil works amongst us, Abu Muslim.

47

AL-MANSOUR: There are only two on this earth I consider fit to counter this sedition: you or me.

ABU MUSLIM: I'm honoured. But I must to Khurasan.

AL-MANSOUR: Why? When Syria and Egypt can be yours?

ABU MUSLIM: Syria and Egypt are nothing more than the untended orchards of Khurasan. Excuse me, brother.

AL-MANSOUR: 'Brother'! To his Calipha, 'brother'!

ABU MUSLIM: Brother in God.

ABU AYYOUB: Will you turn your back on God's Vice-regent and still hope to find heaven?

ABU MUSLIM: (*In Farsi.*) What have I to gain wedging myself between these two men?

ABU AYYOUB: (*In Farsi.*) Think on your soul.

ABU MUSLIM: I have looked into the sea of bodies
that choked on my sword since the dawn of our revolt.
Men killed cold in captivity –
battles aside –
Do you know how many I counted in my sea of dead:
one hundred thousand men,
all floating under these two hands –
my God, that is so many.
WHICH
ONE
OF
YOU
WILL TAKE THESE HANDS
FROM ME?

ABU AYYOUB: (*To IBN AL-MUQAFFA.*) The Calipha is glaring at you.

IBN AL-MUQAFFA: I can see that! Why?

ABU AYYOUB: He's expecting something from you.

IBN AL-MUQAFFA: Like?

ABU AYYOUB: I told him you're an expert in Islamic law.

IBN AL-MUQAFFA: Thanks!

ABU AYYOUB: Sufyan will use your silence as proof.

IBN AL-MUQAFFA: Proof of what?

ABU AYYOUB: That you're Abdullah's man.

IBN AL-MUQAFFA: (*To ABU MUSLIM.*) Allah himself warned of this in his Holy Book.

ABU MUSLIM: What?

IBN AL-MUQAFFA: The dog.

ABU MUSLIM: What dog now?

IBN AL-MUQAFFA: The dog that burdened is found panting and left alone is also found panting.

ABU MUSLIM: (*Taking IBN AL-MUQAFFA by the throat.*) Meaning?

IBN AL-MUQAFFA: Faith, Abu Muslim, faith. To lose it having asserted it is a crime worse than if you had never proclaimed it.

ABU MUSLIM: I sought faith and became an instrument of death.

IBN AL-MUQAFFA: The Calipha is not asking you to make evil –

ABU MUSLIM: I have been death's instrument too long.

IBN AL-MUQAFFA: But to save the world from greater evil.

ABU MUSLIM: Death has made me his own.

IBN AL-MUQAFFA: By taking pre-emptive action.

ABU MUSLIM: More killing.

IBN AL-MUQAFFA: Perhaps; but, in sum, less dead.

ABU MUSLIM: I cannot face more killing.

IBN AL-MUQAFFA: Your soul is burdened now?

ABU MUSLIM: Glutted.

IBN AL-MUQAFFA: Then walk on through all the orchards and valleys of Khurasan, let civil war rage and see if you can make room in your soul for all the bodies still to come.

ABU MUSLIM: I will not have touched them.

IBN AL-MUQAFFA: You will be their murderer.

ABU MUSLIM: This is madness.

IBN AL-MUQAFFA: Truth! A plague is coming and you the doctor with the only known cure want to go walking in the mountains to move closer to your God; are you not worse than the plague – you are the dog the Book warned of!

ABU MUSLIM: (*Screaming.*) God! God! Oh, God, what can bring me to you?! (*He falls to his knees.*)

AL-MANSOUR: Show me your hands that I may bless them.

ABU MUSLIM: I will show you my love.

AL-MANSOUR: Open the windows, the mourning is over. Come Abu Muslim, side by side let us tell the world of its future.

Exit ABU MUSLIM, AL-MANSOUR, followed by others.

Roaring crowds.

IBN AL-MUQAFFA, alone.

IBN AL-MUQAFFA: I came to serve in the House of the Lord
But in befriending the slave,
Grew despised of the master;
In guarding the door,
Let the thief crawl in through the window;
And now, in aiming the arrow,
I've pierced my own heart.

End of Act Two.

ACT THREE

SCENE 1

Enter IBN AL-MUQAFFA.

ABU AYYOUB: Very stylish.

IBN AL-MUQAFFA: What are you doing?

ABU AYYOUB: Waiting for you.

IBN AL-MUQAFFA: Where did you find these?

ABU AYYOUB: They were lying here.

IBN AL-MUQAFFA: They're private.

ABU AYYOUB: Don't be offended. The style is very high, reminiscent of the Koran.

IBN AL-MUQAFFA: Give them to me.

ABU AYYOUB: Don't destroy them on my account.

IBN AL-MUQAFFA: They are practice sheets, that's all.

ABU AYYOUB: I envy you your diligence.

IBN AL-MUQAFFA: What can I do for you?

Enter ABRASH.

ABRASH: Uncle, the horse is –

IBN AL-MUQAFFA silences him with a glance.

ABU AYYOUB: The Calipha's delighted with your performance.

IBN AL-MUQAFFA: I wish I could feel the same way myself.

ABU AYYOUB: He's invited you to join the ranks of his councillors.

IBN AL-MUQAFFA: What?

ABU AYYOUB: You and I together in the eye of the storm.

IBN AL-MUQAFFA: …

ABU AYYOUB: He wants you to begin by giving a reading of your tales to the court tomorrow. Smile, man!

IBN AL-MUQAFFA: No, it's just I –

ABU AYYOUB: You wonder why am I smiling?

IBN AL-MUQAFFA: Yes – no! Do I?

ABU AYYOUB: You've filled your mind with too many Sasannian court thrillers. You think I should be gnawed with jealousy and plotting your downfall?

IBN AL-MUQAFFA: Not at all, a bit overwhelmed, that's all.

ABU AYYOUB: The King's table is filling with the finest of dishes, Ibn Al-Muqaffa, the more that can gorge themselves at the banquet, the merrier – what do you say?

IBN AL-MUQAFFA: Tell the Calipha I'm honoured.

ABU AYYOUB: And your friend Waliba can present his poem this afternoon, I've arranged it all for him.

IBN AL-MUQAFFA: Thank you, Abu Ayyoub, thank you for everything, thank you. I think.

Exit ABU AYYOUB.

ABRASH: Uncle? Where are you sending me?

IBN AL-MUQAFFA: You know the road to Kufa?

ABRASH: Yes.

IBN AL-MUQAFFA: If you ride well, you'll make it there by dawn: change horses and get yourself a guide – a Sabian* if you can find one – who'll take you to Harran. If anyone asks you why you're traveling – hide this pouch of gold – tell them you are a student of astrology and that you need to look at some of the ancient texts.

ABRASH: And when I'm there?

IBN AL-MUQAFFA: Straight to Abdullah's camp. You know your way round slave girls?

ABRASH: They're my favourites! I'll ply them with so many perfumes and cheap bangles – they'll be mine for life!

IBN AL-MUQAFFA: A proper little prince!

ABRASH: Oh if I had my jewels, Uncle – I'd be the plague of slave girls.

IBN AL-MUQAFFA: Just as well your jewels are in the hands of God, then.

ABRASH: A nice way of putting it.

IBN AL-MUQAFFA: Let them take you to Abdullah's daughter, Asia.

ABRASH: Asia 'who carries in her eyes all the splendours of Asia'.

IBN AL-MUQAFFA: Shut up. Give her this. (*Gives him a letter.*) If you avoid his cavalry, you'll be there three days before Abu Muslim.

ABRASH: I won't rest, won't drink, won't breathe till I see her – I'll be faster than a shooting star, Uncle, my tail all on fire!

IBN AL-MUQAFFA: Just don't burn out before you get there. The horse is waiting.

ABRASH: My own horse?!

IBN AL-MUQAFFA: Every day a broken kiln of desire,
Every night a fevered bed of ash
till you're back from Harran. Go!

Exit ABRASH.

SCENE 2

BASHAR: Better wine than Basra, this!

WALIBA: Do try this saffron, I've had it specially ordered.

BASHAR: I love you, Waliba, even though you are a royal bottom bruiser.

IBN AL-MUQAFFA: Let him bruise wherever he thinks they might be hiding their brains.

WALIBA: Won't you sit down, councillor?!

IBN AL-MUQAFFA: Can't sit.

WALIBA:.The burdens of state.

BASHAR: At least can you stop pacing?!

WALIBA: For the moment, I'm copying accounts, but I should hope that one day soon I might reach the inner circle.

BASHAR: Tell us then, account copier, how much do they spend on spies?

WALIBA: Not spies: roads. You can travel from here to Damascus now in five days. Used to be twelve.

BASHAR: Roads for spies.

IBN AL-MUQAFFA: Roads are roads.

BASHAR: Mostly for spies. What was it Al-Mansour said?

IBN AL-MUQAFFA: 'Send out your spies by night to know what happens during the day and send out spies by day to know what happens while you sleep.'

WALIBA: He doesn't sleep. I've seen him in the dead of night poking the earth with his stick, he knows the price of a bag of corn in every governorship. The governor coughs in Sind and Al-Mansour hears it in Iraq.

BASHAR: A spider black in the middle of an ever expanding web,

WALIBA: Ambition without parallel.

BASHAR: The twinges of each expiring fly quivering through his fingertips.

WALIBA: You've heard about the new capital?

BASHAR: Not yet.

WALIBA: Bagh-dad.*

IBN AL-MUQAFFA: The City of God.

WALIBA: I've seen the plans. Breathtaking. Really.

BASHAR: You've quite an admiration for the man?

WALIBA: He's growing on me.

BASHAR: Not surprising with saffron like that on your table. Doesn't come cheap, I imagine.

WALIBA: Do you resent me being able to offer you saffron?

BASHAR: I resent your judgement being obscured by the fumes of the saffron.

WALIBA: What do you mean?

BASHAR: You've become an apologist for a tyrant.

WALIBA: How dare you!

BASHAR: The tyrant's arse kisser!

WALIBA: That's how you repay me for inviting you here?!

IBN AL-MUQAFFA: Listen to him, Waliba, don't get upset.

BASHAR: On Waliba the King empties his colon
Yet Waliba smiles and offers saffron.

WALIBA: Leave my house this instant or I'll call the guards.

BASHAR: Go on then, call them.

WALIBA: I'll tell them what you said.

BASHAR: I'll wait here.

Exit WALIBA.

I've upset our host.

IBN AL-MUQAFFA: He needed to be told: wherever power lunges he leaps, like a fly on a bull's neck.

BASHAR: Ever considered that you're the model he's aspiring to?

IBN AL-MUQAFFA: Someone like Waliba only aspires to himself.

BASHAR: You're one of the court favourites now.

IBN AL-MUQAFFA: And, God knows, I am trying to use that.

BASHAR: To do what again, remind me?

IBN AL-MUQAFFA: To counsel the colossus.

BASHAR: Ah, yes.

IBN AL-MUQAFFA: I'm making a presentation tomorrow to the court.

BASHAR: About what?

IBN AL-MUQAFFA: Not trying to raise a revolution if that's what you mean – I'll leave that to you in your earth shattering stupor!

BASHAR: A colossus! A tribe of henchmen, assassins and thieves and you call them a colossus.

IBN AL-MUQAFFA: We are not power's equal, Bashar, it would be nice if we were, but we are not: we are bits of a broken mirror scattered on the floor. If, however, we are able to nudge power, curb it, incline it, tempt it to bend down and pick us up and see itself through our eyes then do you know what would happen, Bashar, do you? A judge would be a judge for what he knows of law not for what his family knows of corruption; a governor would be a governor to maintain order in a province not to rape its women and enslave its men: that is the revolution I am working on: that is the change.

Enter WALIBA with guards.

…What do you think you are doing?

WALIBA: My duty and yours. Him! The blind one, it was him!

Guards move to arrest BASHAR.

SCENE 3

In AL-MANSOUR's court.

IBN AL-MUQAFFA: (*Reading.*) 'Envy began to gnaw at Dimna the jackal. He saw how quickly the Bull had reached the highest status in the Lion's court, this bull that until recently was nothing more than a stranger from a foreign land.

'How,' asked the King, 'could the Bull ever harm me? I am a carnivore: the Bull is a herbivore. He is my food, I can never be his.'

'Such ideas are made to deceive you,' said Dimna, 'If you are not afraid of Shatrabah the Bull then you should be most wary of your own soldiers; the Bull has lured them into treason.'

– 'What do I do?' asked the Lion, 'what do you suggest?'

'The decayed tooth must be plucked out,' cried Dimna, a drop of saliva falling from his jaw, 'only vomiting will eject poison from the stomach and the only remedy for a treacherous enemy is to kill him!'

Enter SUFYAN.

AL-MANSOUR: Sit down, Sufyan.

IBN AL-MUQAFFA: In this way, Dimna the jackal undermined the King's trust in Shatrabah the Bull who was his friend and loyal servant.

AL-MANSOUR: I find great wisdom in these tales, you are to continue writing them.

IBN AL-MUQAFFA: Thank you, my Lord.

ABU AYYOUB: The story of your Bull resembles the situation with Abu Muslim, I believe.

IBN AL-MUQAFFA: The tale is a parable, please don't read into it more than it can hold.

AL-MANSOUR: You are aware that Abu Muslim is poised to defeat our rebel uncle in Syria?

IBN AL-MUQAFFA: So we hear, my Lord.

AL-MANSOUR: And that some in my court regard Abu Muslim as the next most imminent threat to our security?

IBN AL-MUQAFFA: I am aware of those opinions my Lord.

AL-MANSOUR: Now I want yours.

IBN AL-MUQAFFA: My opinion is that the season for killing is over –

SUFYAN: The Persian protects his own kind.

IBN AL-MUQAFFA: We should stop looking for the enemy within our own ranks.

SUFYAN: And be lulled into complacency.

IBN AL-MUQAFFA: By focusing our minds on the signs of a disease, our bodies engender more of its symptoms.

SUFYAN: It needs no physician to smell a traitor.

IBN AL-MUQAFFA: You see, my Lord, opportunists of limited intellect and doubtful skill with either sword, pen, horse, or book, ignorant of any occupation useful to man other than swilling in the bottomless sewers of their envy, greed and lust will not, simply will not, allow any opinion contrary to theirs to reach the Calipha's ears.

AL-MANSOUR: These are your jackals, I believe?

IBN AL-MUQAFFA: They are, jackals.

SUFYAN: Rabih, there's a messenger outside to see the Calipha.

AL-MANSOUR: Send him in.

SUFYAN: What of Samarkand, my Lord?

AL-MANSOUR: Ten thousand new converts.

SUFYAN: Thanks be to God.

ABU AYYOUB: What's your news, man?

MESSENGER: My Lord, Abu Muslim sends you this message: 'By the grace of God, Al-Mansour, you are victorious, Syria is yours again and Abdullah, father of all my sins, is fled shameless through the night to seek refuge with his brothers in Basra. I am coming to seek your blessing for what I have done.'

AL-MANSOUR: What does that mean?

ABU AYYOUB: We have won, my Lord.

AL-MANSOUR: No. 'Abdullah, father of all my sins,' and 'I'm coming to seek your blessing for what I have done,' what does it mean?

ABU AYYOUB: He's anticipating his reward?

MESSENGER: Lady Asia was wandering lost around the battlefield.

AL-MANSOUR: Then?

MESSENGER: Abu Muslim found her. He has married her.

IBN AL-MUQAFFA: What?

AL-MANSOUR: He dares to marry our cousin!

SUFYAN: He's trying to slip himself into the Line of Muhammed!

ABU AYYOUB: It is treason!

AL-MANSOUR: She must never bear a child.

MESSENGER: Abu Muslim is coming to seek your blessing on this marriage.

AL-MANSOUR: My blessing to knock me off my own throne?!

SUFYAN: That is not the only treason, my Lord.

AL-MANSOUR: What do you mean?

SUFYAN: Bring in the boy.

Enter RABIH with ABRASH tied up and gagged.

AL-MANSOUR: Who is this?

SUFYAN: My Lord, we caught this boy carrying a letter to warn Abdullah of our army's approach.

He has been spared thus far, because he claims he's a slave in this very palace.

AL-MANSOUR: I don't know him.

SUFYAN: Your loyal councillor does.

AL-MANSOUR: (*To IBN AL-MUQAFFA.*) Do you know this boy? (*Long pause.*) …Kill him then.

ABRASH: Uncle!

IBN AL-MUQAFFA: No!

SUFYAN: Treason will out!

IBN AL-MUQAFFA: My Lord it's true, Abrash is my slave. I sent him with a letter aimed at avoiding bloodshed within the Line of Muhammed.

AL-MANSOUR: (*Slaps him.*) Are you more worried about the Line of Muhammed than its members?

IBN AL-MUQAFFA: My Lord, the revolution was based on the sanctity of your family's blood: you are the descendants of the Prophet. That sanctity forms the backbone of order within the state, if blood is shed within the family, all order is broken and chaos will rule. In sending that letter without consulting you I made an error, but believe me by this scribe's hand, I did it for the sake of your rule and not for a moment did I intend that letter to alter the course of your victory.

SUFYAN: What else do you need to end this Manichaean's life?

IBN AL-MUQAFFA: I am a Muslim, not a Manichaean.

SUFYAN: You are a Zindiq!

AL-MANSOUR: Enough! You do not heed the counsel of your own tales, Ibn Al-Muqaffa. Your left hand does not register what your right hand writes. Raise your left hand…

I'll take that one: the boy to do it.

SUFYAN gives ABRASH a knife.

IBN AL-MUQAFFA's left hand is amputed.

End of Act Three.

ACT FOUR

SCENE 1

A tent inside the palace at Al-Anbar.

From without, crowds chanting 'You are God! You are God!'

ABRASH: They're very excited Uncle, are they really maniacs?

IBN AL-MUQAFFA: They're fanatics, boy, not maniacs.

ABRASH: What does a fanatic do, Uncle?

IBN AL-MUQAFFA: A fanatic is one who tastes only the bitterness of this life – Mind the stump.

ABRASH: In that case, I might have to think of joining them.

IBN AL-MUQAFFA: Not as long as I'm schooling your mind. Have you prepared everything for the scene?

ABRASH: Down to the last claw. I've even added a couple of new gestures to the final combat.

IBN AL-MUQAFFA: Emulation, repetition; not idle invention.

ABRASH: Not invention, Uncle, got these off the Chinese prisoners, swapped them for some monkey sounds – they're very ancient, top class.

IBN AL-MUQAFFA: I don't like this.

ABRASH: I'll drop them if you want, Uncle.

IBN AL-MUQAFFA: Not that. It's strange that we should be asked to perform on such a day.

ABRASH: It's a great honour, Uncle, and a sign of how respected you have become.

IBN AL-MUQAFFA: I would rather the tales were read, performing them takes away from their seriousness.

ABRASH: The Calipha was insistent, said he wanted them just like that time you did them for his brother in Basra.

IBN AL-MUQAFFA: That's what worries me.

ABRASH: Who are they calling God, Uncle?

IBN AL-MUQAFFA: The Calipha.

ABRASH: Is that not heresy?

IBN AL-MUQAFFA: For the time being it's publicity. When they've been punished for it, then it can become heresy.

ABRASH: How can a thing be heresy and not heresy?

IBN AL-MUQAFFA: Politics, boy.

ABRASH: But politics, Uncle, is an invention of men, whereas the laws of God –

IBN AL-MUQAFFA: Out of the way now – Abu Muslim's here.

AL-ABRASH withdraws behind the goat's hair screen.

ABU AYYOUB: In addition to maintaining that Al-Mansour carries the soul of God himself, they claim the soul of Adam has transmigrated into your body.

ABU MUSLIM: May God forgive us all.

ABU AYYOUB: You should be proud.

ABU MUSLIM: …

ABU AYYOUB: Even to the diseased imagination you rise next to the Calipha like a twin tower of the Faith.

ABU MUSLIM: We walk along the path God has drawn for us –

ABU AYYOUB: Absolutely.

ABU MUSLIM: …despite the devices of tribes.

RABIH: Your sword, please, my Lord.

ABU MUSLIM: What?

ABU AYYOUB: Sorry – I forgot to mention – the Calipha can no longer bear the sight of weapons.

ABU MUSLIM: Since when?

ABU AYYOUB: Since his Uncle's revolt and this latest monstrosity – they remind him of the divisions in the ranks of the Faithful.

ABU MUSLIM: If he'll see me, he'll see me with my sword.

ABU AYYOUB: The Calipha is fabulously excited, Abu Muslim, don't spoil the occasion by insisting on such a petty detail.

ABU MUSLIM removes his sword.

ABU MUSLIM: Where is he?

ABU AYYOUB: Just praying and on his way. Take the sword, Rabih. Have you instructed your men to deal with this devil's din?

ABU MUSLIM: If the heretics haven't dispersed by sunset, open the city gates and my army will charge.

ABU AYYOUB: God reward you. You remember, Ibn Al-Muqaffa?

ABU MUSLIM: How could I forget the tamer of my lion soul?

IBN AL-MUQAFFA: Your soul could never be tamed, my Lord, only – perhaps – counseled towards greater glory.

ABU MUSLIM: There is no greater glory than love.

ABU AYYOUB: Of God.

ABU MUSLIM: Love.

IBN AL-MUQAFFA: Is your wife with you, my Lord? Lady Asia?

ABU MUSLIM: She is always with me. You lost an arm?

IBN AL-MUQAFFA: Just a hand. A hand is not a heart.

A flap of the tent is opened and AL-MANSOUR enters with two men in animal masks. As the gathered lower their heads in respect, ABRASH is picked up in silence and led off by the men.

AL-MANSOUR: Rise. Abu Muslim. My beloved.

ABU MUSLIM: They have taken away my sword.

AL-MANSOUR: Who did that to you?

ABU AYYOUB: It was me, my Lord.

AL-MANSOUR: Go and fetch it.

ABU AYYOUB: I thought that –

AL-MANSOUR: Son of an uncircumcised bitch! Is he not the Trusted One of the Family of the Prophet?! (*To ABU MUSLIM.*) You must be tired after your journey.

ABU MUSLIM: I have had time to bathe and pray.

AL-MANSOUR: Excellent. We've prepared some entertainment for you.

ABU MUSLIM: It's not our habit.

AL-MANSOUR: Nor ours. But we have discovered much of worth in this latest form of...what did you call it?

IBN AL-MUQAFFA: Counsel through pleasure, my Lord.

AL-MANSOUR: Do you know the story of the Lion and the Bull?

ABU MUSLIM: It's all over the camps, but I have never heard it.

AL-MANSOUR: The novelty will sharpen your enjoyment.

ABU MUSLIM: My Imam, forgive me. Such foibles make a Muslim lose his mind.

AL-MANSOUR: We are alike; we set great store by the mind. Come sit by your Imam: have faith. Leave us, ministers. Begin!

ABU MUSLIM: Which part is this?

AL-MANSOUR: The battle scene, of course.

A curtain opens. Enter BULL and LION with weapons.

LION: And so all the animals did gather to witness the meeting of the Lion...

BULL: ...and the Bull. For all had heard how suspicion had grown between them and all anticipated a great battle.

IBN AL-MUQAFFA: Abrash? Abrash!

AL-MANSOUR: Rabih: we will not be interrupted!

IBN AL-MUQAFFA: Take your hands off me!

ABU AYYOUB: Quiet or he'll strangle you.

ABU MUSLIM: What are they carrying?

AL-MANSOUR: Maces.

ABU MUSLIM: Real ones?

AL-MANSOUR: Toys.

LION: From the East, my Bull?

64

BULL: Your servant.

LION: Victorious in your battles against the dogs.

BULL: Urged on by our prayers and the will of God.

LION: Your tail is twitching – what are you hiding from me?

BULL: This: the muzzle of the Prince of Dogs.

LION: My mane tingles to see it, but your tail is still twitching.

BULL: It must be the flies.

LION: Still twitching...

BULL: Perhaps it's your eyes?

LION: But wait! Is this not the tale that prods our cousin?

BULL: Poke is the word you're looking for – 'pokes our cousin'.

LION: A joke?

BULL: Rotten. Don't eat it.

ABU MUSLIM: Is this the story?

AL-MANSOUR: Is it to your taste?

ABU MUSLIM: They speak too much like humans, is there no heresy in it?

AL-MANSOUR: None.

ABU MUSLIM: Who wrote it?

AL-MANSOUR: Ibn Al-Muqaffa.

LION: You know how much this war cost us?

BULL: I can imagine.

LION: Where, then, are my spoils?

BULL: I thought it wiser to distribute them to the soldiers for pay.

LION: Lucky soldiers that chew the grass I send them and devour my spoils.

BULL: You did not see the battle we had to fight.

LION: After the kindness I have shown you.

BULL: Can't you see my wounds?

LION: After all I have given you.

BULL: Nothing I would not have taken myself.

LION: Now you talk with your real tongue, traitor! Give me my honour!

BULL: It's here.

LION: Where?

BULL: On the tip of my horns.

LION: Son of a provincial slave, how high you've climbed.

BULL: The Bull is no longer your servant.

LION: Because the Bull is dead!

They pull back from one another, and prepare to strike.

ABU MUSLIM: Look how the Bull breathes.

AL-MANSOUR: And the Lion rolls his eyes.

ABU MUSLIM: Excellent entertainment.

AL-MANSOUR claps his hands.

The animals turn to face ABU MUSLIM.

Have they stopped?

AL-MANSOUR: Keep your eyes open; watch how History begins.

IBN AL-MUQAFFA: A travesty! I won't allow it!

RABIH strikes IBN AL-MUQAFFA across the head, he falls unconscious.

The LION and the BULL pummel ABU MUSLIM with their maces.

AL-MANSOUR: Stop! You're bleeding.

ABU MUSLIM: Spare me to fight your enemies.

AL-MANSOUR: What enemies has God given me worse then you?

ABU MUSLIM: I loved you.

AL-MANSOUR: Don't speak of love, you don't understand love, only mothers can speak of love. You are a debt collector, nothing more: give him the debt he claimed could never be paid, let him drink from the cup he gave others to drink from!

They strike ABU MUSLIM.

I am the mother of a terrible child
I carry it
In my veins I carry it
Do not look at my child
it will tear your eyes out
Do not claim to have fathered this child
For all its fathers have been dismembered
Do not come near me when I am fat with this child
This child is Empire:
That is love!

ABU MUSLIM is dead.

Exit AL-MANSOUR, RABIH and Assassins.

SCENE 2

The same.

Sound of Rawandians chanting 'You are God! You are God' has increased.

ABU AYYOUB: The Revolution is twitching at my feet.

SUFYAN: Is the Revolution a Persian sorcerer? There was a thorn in the Revolution's little finger. That thorn has now been removed.

ABU AYYOUB: A thorn? We are in a tent, Sufyan, in the middle of a city filled with fanatics who think this man was Adam. Now we also have, just outside the city walls, a second group of maniacs who are this man's army – oh – only twenty thousand of them, nothing to worry about – a thorn bush shall we say?

SUFYAN: They are fields of roses, longing to be tended.

ABU AYYOUB: No – they are the terror of Byzantium!

SUFYAN: There is a blinding light that guides this revolution, Abu Ayyoub, the Calipha has seen this light and runs in a race with the vision of God. Arabs run with him, Muslims run with him – we are the blood that pounds through his veins.

IBN AL-MUQAFFA who, until this point has been contemplating ABU MUSLIM's body in silence, is suddenly violently sick.

ABU AYYOUB: Oh!

SUFYAN: But perhaps you and your sickly companion run in another race?

ABU AYYOUB: On the contrary, I just love running.

Enter RABIH.

RABIH: Abu Muslim's army has sent word.

ABU AYYOUB: What do they want?

RABIH: They want to see Abu Muslim emerge safely out of this tent before sunset.

ABU AYYOUB: Oh, that's wonderful. Delightful! God, show me your light, let me run towards it, let me leap, let me dash, let me sprint!

Enter AL-MANSOUR, in new regalia.

AL-MANSOUR: Be quiet, she-goat! Two snakes have coiled themselves around me. Now councillors, advise me. Ibn Al-Muqaffa?

IBN AL-MUQAFFA: Forgive me, my Lord, I cannot speak, I cannot think!

AL-MANSOUR: Can't speak, can't think. Sufyan, did Ibn Al-Muqaffa die too?

SUFYAN: Only whisper the word my Lord.

IBN AL-MUQAFFA: You will dine with Abu Muslim tonight.

AL-MANSOUR: You are not fit for prophecy, scribe!

IBN AL-MUQAFFA: Not prophecy, my Lord. Announce that you will dine together, and make great show of the preparations, bring another tent, bring carpets and pots of food, they will see the preparations and be satisfied for the night.

AL-MANSOUR: And in the morning? No. I will enter the fight, in these white robes. Wrap Abu Muslim in a carpet and attach him to the mount of our most trusted horseman. When the people see me fighting the heretics they will flood to my side. Then, when the dust has risen, drop Abu Muslim's body into the fray and spread word that the heretics have killed him. Open the doors of the city, allow Abu Muslim's army to enter and release their frenzy on the throng of heretics, a massacre will follow and the mouth of one snake will close on the head of the other.

Enter ASIA.

IBN AL-MUQAFFA: Asia!

ASIA: I want my husband's body.

AL-MANSOUR: His body is the nation's, cousin, and not mine to give.

ASIA: You are the nation.

AL-MANSOUR: You are deluded.

ASIA: Then the nation is a lie.

IBN AL-MUQAFFA: Asia –

ASIA: Don't touch me!

SUFYAN: She's mad, my Lord, the sorceror has stolen her mind.

ASIA: Do you know how I found love Al-Mansour? I found it in the arms of a man who has killed more men than leaves fall from a tree. The first time I kissed him, he rolled on the floor in agonies of pain and when I held him in my arms he wept. For three days he wept and cried for God. Through his agony I learnt more about life than I ever learnt from court or scholar. That merciless man found forgiveness in my arms and in finding forgiveness he lost his need for

God…he walked into death like a child walks over an open balcony. You did not kill him: he gave himself to you.

Exit ASIA.

AL-MANSOUR: Ibn Al-Muqaffa stay with her; don't let this derangement seep beyond our palace walls.

Exit IBN AL-MUQAFFA.

RABIH: My Lord, the sun sets within the hour.

SUFYAN: Let me be your most trusted horseman, tie Abu Muslim's corpse to my horse.

AL-MANSOUR: Then fetch us two white steeds.

Exit SUFYAN.

Abu Ayyoub, follow Ibn Al-Muqaffa and be as watchful of him as others will be of you. God watches, God sees, Abu Ayyoub: man is never alone – except in death.

Exit ABU AYYOUB.

SCENE 3

IBN AL-MUQAFFA: Asia!

ASIA: Away, hypocrite!

IBN AL-MUQAFFA: I was not responsible for Abu Muslim's death.

ASIA: Never imagined you could be.

IBN AL-MUQAFFA: They twisted my words, Asia, distorted them beyond recognition.

ASIA: Because you taught your words treachery –

IBN AL-MUQAFFA: Sending Abu Muslim to fight your father, yes that was me, I was forced into it –

ASIA: The supreme court intriguer –

IBN AL-MUQAFFA: I tried to warn you both, I sent you my boy –

ASIA: The archetypal blunderer.

IBN AL-MUQAFFA: You believed in me once.

ASIA: I was wrong.

IBN AL-MUQAFFA: I'm sorry if I haven't slaughtered enough men for you to love me!

ASIA: You should have gone to Jur.

IBN AL-MUQAFFA: I underestimated man's potential for evil –

ASIA: Tended apples, ploughed some earth

IBN AL-MUQAFFA: But now I've seen it, studied it, wiped it off my clothes.

ASIA: You would have made a happy peasant.

IBN AL-MUQAFFA: Listen to the cries of men dying – what can I write to stop that, what? All I can do is pickle that bitterness to castigate generations to come; I don't command an army.

Enter ABU AYYOUB, unseen.

ASIA: Did I ever promise to love you?

IBN AL-MUQAFFA: In Basra once, you promised me something.

ASIA: The Scribe seeks redemption
From a woman's heart in Basra
He seeks redemption
when Basra is in ruins!

IBN AL-MUQAFFA: I don't need your charity, Asia and not all skiffs of worth in this world are moored in a king's court. You led me here and I followed like an idiot child sucking on a stick of honey. I didn't notice the whacking stench of blood in the courtyard, I was too busy dangling my fingers in the gold rose-water bowls, didn't even notice pieces of my own body fly around me. I've had my little mountain trek with Power – thankyou very much – but the views really weren't worth waiting for. I'm leaving this court, Asia and I'm leaving you: Whale hunters can't be gulled with minnows and writers with vision can't be stumped by kings, princes and…prawns!!

ASIA: Signs. I see signs.

IBN AL-MUQAFFA: Oh God.

ASIA: I see a veil fall over a sleeping face
Birds of prey eclipse the sun.
There, beyond the city walls,
I see a pack of wolves tearing a man apart
His limbs are not of flesh
But of light,
Lanterns scatter over dark hills.

IBN AL-MUQAFFA: I'll get you some water.

ASIA: Stay! Have you finished your tales?

IBN AL-MUQAFFA: Not yet.

ASIA: But you know how to end them?

IBN AL-MUQAFFA: Yes.

ASIA: Teach me the tales and teach me their ending.

IBN AL-MUQAFFA: Why?

ASIA: I will teach them to my maid, who will whisper them
to her lover who will recite them to his general who will
slip them to his paymaster who passes them to a merchant
who carries them to the silk slaves in China, the spice
farms in Yemen, the amber mines in India, in these tales I
see lanterns threading through the night – from them, Ibn
Al-Muqaffa, comes the real book, the real religion, the real
empire.

IBN AL-MUQAFFA: Asia, this is heresy.

ASIA: No it is God's will. Teach me your tales, each word will
raise an army!

IBN AL-MUQAFFA sees ABU AYYOUB.

IBN AL-MUQAFFA: You are hallucinating. I'll find you a
physician.

Exit.

SCENE 4

A dinner in the palace, night.

They are sat formally and by rank. IBN AL-MUQAFFA and WALIBA are seated in the foreground, behind them in a row are the Rulers.

IBN AL-MUQAFFA: What are you doing here?

WALIBA: I'm the court historian.

IBN AL-MUQAFFA: Court what?!

WALIBA: I'm writing the history. Look at Sufyan, still dripping in blood.

SULAIMAN BIN ALI: A most excellent meal to crown a most excellent victory, Nephew!

ABU AYYOUB: The Calipha is fabulously excited that his uncle has chosen to visit him in the Holy Month.

IBN AL-MUQAFFA: What's of Bashar?

WALIBA: Bashar?

IBN AL-MUQAFFA: Our friend, Waliba. The one you had arrested.

SULAIMAN BIN ALI: I'm only sorry I arrived too late to join in the scrape. You've clearly made quite a meal of them.

ABU AYYOUB: Your arrival on the night of this great victory is a blessed sign.

IBN AL-MUQAFFA: Look me in the eye, Waliba, and tell me what's happened to Bashar.

WALIBA: Ask the authorities dealing with him!

SULAIMAN BIN ALI: Perhaps it's time you got yourself cleaned up, Sufyan?

ABU AYYOUB: The Calipha has asked my Lord Sufyan not to wash so that the memory of today's great battle may colour our thoughts.

SULAIMAN BIN ALI: Is this milk off?

AL-MANSOUR: Have you ever heard of a lion-man, Uncle?

SULAIMAN BIN ALI: I think I have. Rabih! Do you know my herdsman? (*Rising.*)

WALIBA: What are lion-men?

IBN AL-MUQAFFA: Objects of a despotic fantasy.

SULAIMAN BIN ALI: (*Continuing to RABIH who is stood by the door.*) Ask him to milk one of my camels into a large flagon with some honey would you – and ask him to...

IBN AL-MUQAFFA: (*To AL-MANSOUR.*) I need to retire from the court for a few weeks.

AL-MANSOUR: Why?

IBN AL-MUQAFFA: To write in solitude.

AL-MANSOUR: Solitude?

IBN AL-MUQAFFA: Yes.

AL-MANSOUR: Solitude is not healthy for a writer.

ABU AYYOUB: Look at our new friend Waliba, here, doesn't know the meaning of the word do you, Waliba?

They laugh.

WALIBA: Should I erase that remark from the history, my Lord?

AL-MANSOUR: We are awaiting your tales, Muqaffa.

IBN AL-MUQAFFA: That's why I need time to –

AL-MANSOUR: No! Abu Ayyoub – find him somewhere he won't be disturbed.

IBN AL-MUQAFFA: Don't bother. You"ll have the tales within a week.

IBN AL-MUQAFFA rejoins WALIBA downstage as SULAIMAN returns to the others and remains standing.

WALIBA: (*To IBN AL-MUQAFFA.*) You did not call him my Lord once in that conversation, I think you've lost your mind.

SULAIMAN BIN ALI: (*To AL-MANSOUR.*) Lion-men. They are creatures of Nabatean mythology, I believe?

ABU AYYOUB: Much earlier – Babylonian.

AL-MANSOUR: If you had seen Sufyan in the battle today, slashing his way through curtains of blood, then you'd know the meaning of a lion-man.

SUFYAN: Whatever comes from me in its fullness comes from God and whatever comes from me and is lacking comes from my Self and the work of Satan.

SULAIMAN BIN ALI: Satan himself? Aren't you the lucky one!

SUFYAN: Satan is everywhere and is best hunted amongst one's inner thoughts.

SULAIMAN BIN ALI: And one's inner garments, perhaps? (*He laughs.*) I'm sorry, I hadn't realised zealotry was so fashionable in the privacy of our own chambers, nephew.

AL-MANSOUR: What privacy, Uncle? (*Pause.*) Sit down where you are and Sufyan, come sit on my right hand.

SULAIMAN BIN ALI: Why? Is that all?

WALIBA: Does that mean something?

IBN AL-MUQAFFA: You disgust me.

AL-MANSOUR: What prevented our Uncle Abdullah from coming to see me with his family?

SULAIMAN BIN ALI: The chase, nephew. He is inordinately fond of pursuing animals, beasts make him forget his family and himself!

IBN AL-MUQAFFA: (*To the Rulers.*) I know the feeling, animals everywhere these days! (*The Rulers stare at him.*) Carry on, please.

SULAIMAN BIN ALI: (*RABIH enters and offers SULAIMAN the camel's milk.*) Take milk to the Calipha.

WALIBA: Are you mad?

IBN AL-MUQAFFA: No, I'm recovering my sanity.

AL-MANSOUR: (*Throwing the milk at RABIH.*) What are you doing you obscenity!

SULAIMAN BIN ALI: There's really no need –

IBN AL-MUQAFFA: (*Throws his glass of milk at WALIBA.*)

WALIBA: How dare you!

IBN AL-MUQAFFA laughs.

AL-MANSOUR: Sufyan! A man of the Arabs, stout of soul, skilled in war, and of the noblest blood! Take Basra Sufyan. Govern it in my name. Basra is yours.

SULAIMAN BIN ALI: And me?

AL-MANSOUR: (*To SUFYAN.*) Take ten thousand dinars with you.

SULAIMAN BIN ALI: You jest!

AL-MANSOUR: You are to us in blood what we don't want to lose, Uncle – stay close! Always!

SULAIMAN BIN ALI: For God's sake, Al-Mansour! His eyes are popping out!

AL-MANSOUR: I need you to look after Asia, she's very ill.

SULAIMAN BIN ALI: He's never seen that kind of money in his life – look at him, he's already spent it!

AL-MANSOUR: He is worth a thousand of each of you! (*Closes his eyes.*) Move away from me all of you. (*Draws his sword.*) Stop! (*Cuts a circle through the air with his sword.*) That is the reverent distance all men will keep from God's Shadow on this earth.

A great shadow falls across the stage. The assembled bow to their knees one by one. IBN AL-MUQAFFA remains standing.

IBN AL-MUQAFFA: (*To WALIBA.*) Watch! Historical event. (*He walks across the stage.*) Write it down. (*He exits.*)

A solitary lantern moves swiftly across the stage.

End of Act Four.

ACT FIVE

SCENE 1

A palace fever. Multiple scenes, actions and characters overlap, fuse into focus and then disperse.

IBN AL-MUQAFFA: In this tale, the divine colours and contours of the world came into focus and bloomed as Dimna the Jackal won the She-Lion's love. Only once, in the piercing hoot of an owl did his snout catch a scent of some forthcoming doom.

ASIA: Ink.

IBN AL-MUQAFFA: Enough of this – call back your maid!

ASIA: ...

IBN AL-MUQAFFA: Make her bring back her lover!

ASIA: Your lips have turned blue.

IBN AL-MUQAFFA: I don't want the tales spread –

ASIA: It's too late. The lover came in the night. He's been to the General who spoke to the merchant at the dead of noon who's whispering the tales now this minute into the ears of his whore who'll take them –

IBN AL-MUQAFFA: Stop it! The court can smell blood, Asia, I can hear them howling.

ASIA: Empires rise with the howling of wolves.

IBN AL-MUQAFFA: And men crumble with the flight of birds.

ASIA: Let's stop for tonight.

IBN AL-MUQAFFA: No –

ASIA: You're exhausted.

IBN AL-MUQAFFA: Write, will you? Just write! In that season, crows gathered on the palace gates to recite dark prophecies and terrified birds got trapped in ladies' bedrooms.

ABRASH: Oh, Uncle!

IBN AL-MUQAFFA: Won't you learn to knock boy!

ABRASH: I went to the prison.

IBN AL-MUQAFFA: And?

ASIA: What's the matter?

IBN AL-MUQAFFA: Did you see Bashar?

ABRASH: Bashar says you must leave the palace tonight.

IBN AL-MUQAFFA: Why?

ABRASH: Your tales are all over the prisons, Uncle: the prisoners are planning a riot.

ASIA: God be praised!

IBN AL-MUQAFFA: The She-Lion saw great portent in these signs and as the fame of the Jackal's stories spread beyond the court, his tales were mouthed in turn by both his enemies and his friends.

ABU AYYOUB to AL-MANSOUR.

ABU AYYOUB: A black bull and a white bull grazing together, back to back; impossible for the hungry lion to attack. Enter the Jackal to the Bull in black, 'Never noticed how the white bull always finds the greenest plots of grass? While you chomp on burnt scrub and bits of twig? Look at your lips: chapped and sore; now look at his: plump, red, rosy, more! Look at your flesh that sags off your bones like a bag on a stick: look at his – muscled and toned like a saddle. Why is that? Ha?! Because you are Black and he is White, because he knows you dare not bite?!'. One morning as they grazed, the Black Bull turned on the White Bull and gored him. Now the Lion moves in to take his pick.

AL-MANSOUR: Discard the Lion, keep the Jackal and the Bulls. Spread that story to the regions of Mecca and the Hijaz. There are some Shia hiding there that we want the good people of Mecca to help us flush out. When do we receive the rest of the tales?

ABU AYYOUB: Tomorrow, if he's kept his promise.

AL-MANSOUR: I want five hundred illuminated copies made and one handed to every Security Chief, Mufti and Governor in the realm.

ABU AYYOUB: Five hundred?

AL-MANSOUR: I'll put my gloss in them first. Ah, there you are!

IBN AL-MUQAFFA: Sorry, my Lord, my mind was elsewhere.

AL-MANSOUR: Very good those Bulls! You look quite ill, Muqaffa', what's wrong?

ABU AYYOUB: Is it love?

AL-MANSOUR: Where are the illuminators?

ABU AYYOUB: Studying petal structures in the garden.

AL-MANSOUR: Summon one of them to touch up Muqaffa's cheek with carmine red.

IBN AL-MUQAFFA: Please leave them to the study of petals.

AL-MANSOUR: Cheeks first, then petals.

ASIA: My body is the map of your empire.

IBN AL-MUQAFFA: Name me its parts.

ASIA: Ask and I'll tell you.

IBN AL-MUQAFFA: The rude pupils of these blind eyes?

ASIA: The domes of Isfahan. Surrendered to your cupped hands and open mouth. Revolt took hold there a week ago.

IBN AL-MUQAFFA: These shifting sands.

ASIA: The Mervian plains. Rubbed smooth by your fingertips. News of a revolt arrived from there yesterday.

IBN AL-MUQAFFA: These lips that will not utter my anguish.

ASIA: The borders of China.

IBN AL-MUQAFFA: When will the wisdom of China be mine?

ASIA: It's dark. Please remove your hand.

IBN AL-MUQAFFA: My tales are the lanterns scattering over dark hills?

ASIA: They are. Remove it please.

IBN AL-MUQAFFA: They throw a light that blasts through the Shadow of God?

ASIA: Yes. Take away your hand please.

IBN AL-MUQAFFA: And in that light all Kings are shown to dangle in their paltry human rags?

ASIA: Yes. Stop it, I said.

IBN AL-MUQAFFA: Wherever my lanterns fall, fires are set alight.

ASIA: No more!

IBN AL-MUQAFFA: And in those flames men see the real contours of God?

ASIA: Oh God!

IBN AL-MUQAFFA: Asia, am I the sage outside the walls being ripped apart by wolves?

ASIA: No, you are inside me.

IBN AL-MUQAFFA: And one night, as the Jackal wandered along the edges of the palace, he saw a group of scribes gathered around the crow listening to a dark prophecy.

As IBN AL-MUQAFFA approaches the group of men, they peel apart and SUFYAN emerges carrying the head of IBN AL-MUQAFFA.

Oh God!

SUFYAN: God? God what heretic, God watches me? Or are his eyes are made of stone, ha?

ASIA: Quiet, my love, you are in a fever.

SUFYAN: Watching me, he'll reward me for God hates you too.

IBN AL-MUQAFFA: And so passed many nights with the Jackal unable to be sure if he was the teller of his tales or if the tales were telling him.

IBN AL-MUQAFFA sleeps, ASIA exits.

SCENE 2

Enter SUFYAN with WALIBA.

SUFYAN: Five hundred copies?

ABU AYYOUB: One to every governor, mufti and general.

SUFYAN: Is Al-Mansour doting?

ABU AYYOUB: Thirty illuminators arrived from Shiraz today to paint the books.

SUFYAN: I have to steep my body in wounds before Al-Mansour deigns to look at me and this feather pushing Persian can do no wrong –

ABU AYYOUB: Don't think it's because he's a Persian –

SUFYAN: What next, make him a Minister? Of Scribes, why not, instead of you?

ABU AYYOUB: Or Governor of a province? Not Basra, of course – a minor one, I mean.

Pause. SUFYAN steps back.

WALIBA begins to twirl like a dervish.

…You know Tabaristan, Khazaristan …I think it's safe to forget him?

SUFYAN: Deliver him to me in Basra.

ABU AYYOUB: I see.

SUFYAN: Yes, you bring him to me.

ABU AYYOUB: He's a member of the Calipha's closest inner circle, I can't touch him.

WALIBA: *(Singing.)* The court is like a spinning lathe.

SUFYAN: Anyone ever told you that you two look alike?

ABU AYYOUB: Who?

SUFYAN: You and Ibn Al-Muqaffa.

WALIBA: The courtiers wet pieces of clay,

ABU AYYOUB: I don't think so.

SUFYAN: Last time I was in Basra, that man insulted me in public.

ABU AYYOUB: Really?

SUFYAN: Before my tribe and kinsmen, in public by the broad light of day, hot blooded men my tribe and kinsmen, Abu Ayyoub.

ABU AYYOUB: Surely that's all been forgotten?

WALIBA: Sleepless with the shape power gives them,

SUFYAN: I fear, the next time you're in Basra, my kinsmen may mistake you for him, put your head on a pole and force me to say that he…was you!

Exit SUFYAN.

WALIBA: Until all their enemies are in the oven.

WALIBA twirls.

SCENE 3

ABU AYYOUB: All done with the tales?

IBN AL-MUQAFFA: Not quite, I was just –

ABU AYYOUB: I want to be your mouthpiece!

IBN AL-MUQAFFA: Abu Ayyoub!

ABU AYYOUB: I want to pour your merits into the Calipha's ear, moulding that thought, that possibility, that idea that allows you to return to his bosom unscathed. But I need you to work with me!

IBN AL-MUQAFFA: Of course, but –

ABU AYYOUB: Leave the court and you are nobody.

IBN AL-MUQAFFA: That's exactly what I want.

ABU AYYOUB: Sufyan too. I've tried to warn you.

IBN AL-MUQAFFA: Wait! I'm listening.

ABU AYYOUB: Mansour wants his Uncle Abdullah to visit him here in the palace, to settle their differences face to face.

IBN AL-MUQAFFA: Then he should summon him.

ABU AYYOUB: Abdullah's demanding a letter of safe conduct.

IBN AL-MUQAFFA: Well it's a standard format, with five or six variations.

ABU AYYOUB: All have been rejected. Both sense the other is plotting in ways words can't control. You can write it in a form they can both agree on.

IBN AL-MUQAFFA: You can find dozens of scribes to do that.

ABU AYYOUB: You are closer to Abdullah than anyone.

IBN AL-MUQAFFA: Hardly.

ABU AYYOUB: And his daughter, Asia.

IBN AL-MUQAFFA: I don't see how that –

ABU AYYOUB: There are no little secrets in this court, Ibn Al-Muqaffa, not a rutting in the night, not a fold on your skin, nothing hides from me – do you hear me clearly?

IBN AL-MUQAFFA: You're my watcher, my jackal.

ABU AYYOUB: (*Grabs IBN AL-MUQAFFA's head.*) What do I owe you to keep a secret like this?

IBN AL-MUQAFFA: I don't think we owe each other anything do we, Abu Ayyoub?

ABU AYYOUB: Don't ever say that!

IBN AL-MUQAFFA: Tell Al-Mansour what you know – I'm no longer available for court duties – or court games.

ABU AYYOUB: We are the Persians in this Arab court, Rawzabah, we are the only two. If I lose you, I lose myself and if we two are gone, the whole line of Persia recedes into the sands!

IBN AL-MUQAFFA: Never heard you speak of yourself as a Persian before.

ABU AYYOUB: You think I like playing at being a Muslim?

IBN AL-MUQAFFA: You think I play at being a Muslim?

ABU AYYOUB: Go to Basra, rise in Basra: keep Al-Mansour indebted to you, don't desert your people now – they're coming.

IBN AL-MUQAFFA: Who is?

ABU AYYOUB: The entire court!

The Court enters.

SCENE 4

ABU AYYOUB: Scribe, present your work in the High Style.

IBN AL-MUQAFFA: I Abdullah Ibn Al-Muqaffa make liberty of the tales of Kalila wa Dimna to Abu Ja'afar Al-Mansour, Leader of the Faithful and God's Shadow on this Earth, long may he live and profit from them.

As the courtiers begin to howl, IBN AL-MUQAFFA places the tales on a pair of scales and RABIH matches their weight in gold coins.

AL-MANSOUR: This prison upset.

IBN AL-MUQAFFA: Yes, my Lord.

AL-MANSOUR: And the revolt in Merv.

IBN AL-MUQAFFA: Yes, my Lord.

AL-MANSOUR: They say it was set off by a copy of your tales. Truth?

IBN AL-MUQAFFA: The only copy on earth is in your hands.

RABIH hands AL-MANSOUR the pouch of gold.

AL-MANSOUR: Truth does not weigh much in gold does it? (*AL-MANSOUR fills IBN AL-MUQAFFA's mouth with gold.*) Your requests, scribe?

IBN AL-MUQAFFA: (*He spits out the gold.*) That Bashar Ibn Burd be released from prison.

AL-MANSOUR: And?

IBN AL-MUQAFFA: Nothing, my Lord.

AL-MANSOUR: And the court falls like a pearl from his hands. Asia?

ASIA: Yes?

ABU AYYOUB: My Lord, my friend's modesty prevents him. I know he wishes to ask you for something yet his tongue –

IBN AL-MUQAFFA: No, I don't.

AL-MANSOUR: (*To ASIA.*) Sufyan leaves for Basra tomorrow and it has been arranged that you shall travel with him.

ASIA: How is it I have not been told of this?

SULAIMAN BIN ALI: We noticed with concern your growing affliction and blame only ourselves. You must rejoin your father.

IBN AL-MUQAFFA: My Lord, I do have a request: that I be allowed to serve you one more time.

AL-MANSOUR: Yes.

IBN AL-MUQAFFA: I want to go to Basra to compose the letter of safe conduct that will bring Abdullah Bin Ali to your court in peace.

AL-MANSOUR: Sulaiman?

SULAIMAN BIN ALI: I can think of no better man in Iraq.

AL-MANSOUR: Very good.

SUFYAN: Then we'll all travel together.

ABU AYYOUB: Perfect!

IBN AL-MUQAFFA stares at ABU AYYOUB. Pause.

IBN AL-MUQAFFA: I fear to travel without a guard.

SUFYAN: You'll be quite safe with me.

IBN AL-MUQAFFA: I fear Sufyan will make ill towards me on this journey.

SUFYAN: Let Sufyan kiss you in the eyes of the world and if harm should come to you from any malignant hand, let them say Sufyan did it!

IBN AL-MUQAFFA: Keep away from me!

AL-MANSOUR: Sufyan would not dare lay a finger on you; he knows what seat you hold in my bosom. Go, all of you, carry my love to Basra.

SUFYAN embraces ABU AYYOUB.

Howling from the court.

SCENE 5

The road to Basra.

BASHAR: Why are you following her?

IBN AL-MUQAFFA: To protect her.

BASHAR: Killer that you are.

IBN AL-MUQAFFA: I'm going to write a letter that will protect her and her father.

BASHAR: I'll write it for you – be a much better letter. Now, get on your horse and get lost –

IBN AL-MUQAFFA: No.

BASHAR: You are not coming to Basra.

IBN AL-MUQAFFA: 'Dip your pen in blood,' as Abdulhameed used to say.

BASHAR: 'Cling to life!' is what he said to you.

IBN AL-MUQAFFA: There are two types of failure, Bashar, one in life and one in love and I have tasted both.

BASHAR: Heart failure under torture – tasted that yet?

IBN AL-MUQAFFA: Failed in my counsel, failed in the court –

BASHAR: Eye gouged out with a poker?

IBN AL-MUQAFFA: Failed in my faith –

BASHAR: All your ribs broken with a mallet?

IBN AL-MUQAFFA: Failed in almost everything I've ever put my hand to.

BASHAR: Do you know the sound that makes?

IBN AL-MUQAFFA: You're not listening to me!

BASHAR: You don't know what can be done to a body!

IBN AL-MUQAFFA: You don't know what can be done to a soul!

BASHAR: Leave her!

IBN AL-MUQAFFA: I won't! Failure in life is something we are schooled to avoid, Bashar, but failure in life is, in fact, the very condition of anything other than utter mediocrity.

BASHAR: So?

IBN AL-MUQAFFA: But failure in love, no, that is something else – that is colder to me than the grave itself.

BASHAR: Pour your tears onto the pagan altar,
But be Mistress Failure a pretty lass,
Then, oh my fearless rhyme, fear not to…falter.

IBN AL-MUQAFFA: Take this, would you? It's a copy of the tales. Hide them for me, and add to them if you need to.

BASHAR: Add what?

IBN AL-MUQAFFA: Keep them current.

BASHAR: God! Strike this man with lightning! Please God strike sense into his wasting, addled brain!

IBN AL-MUQAFFA: (*Quietly.*) Look.

BASHAR: More genius! Look, to Bashar Ibn Burd, look!

IBN AL-MUQAFFA: A ring of fire – it's Baghdad.

BASHAR: Baghdad?!

IBN AL-MUQAFFA: Al-Mansour wanted to see the city before they build it, so they've drawn it out for him in real scale.

BASHAR: Describe it to me.

IBN AL-MUQAFFA: An image of the universe: a circular city wall ten miles wide and, in the dead centre, a mosque and a palace.

BASHAR: Which is bigger; mosque or palace?

IBN AL-MUQAFFA: Palace. The perimeter is the halo and the palace is God.

BASHAR: Why is it on fire?

IBN AL-MUQAFFA: To see it! They used ropes of wool doused in tar. The sky is orange.

BASHAR: Black night opened its wreaking orange gob
Wide as an oven stoked on poor human sods!

IBN AL-MUQAFFA: Let's move on.

BASHAR: Who's screaming?

IBN AL-MUQAFFA: Peasants. Their houses are on fire.

BASHAR: Can't Colossus hear them?

IBN AL-MUQAFFA: They're not part of the plan.

BASHAR: Course not. (*Shouting as they exit.*) Co-lo-ss-aaaass!!
Co-lo-sssaaaassss!!

SCENE 6

Multiple scenes overlapping.

ABU AYYOUB: I have found a copy of the rebel tales.

SUFYAN: Where?

ABU AYYOUB: A copier in the souk.

SUFYAN: Does it differ from Al-Mansour's?

ABU AYYOUB: Significantly. There's even a chapter that questions man's need for God.

SUFYAN: Heretic.

ABU AYYOUB: Certainly not something I would have written.

SUFYAN: Where is he now?

ABU AYYOUB: He's bringing you the letter of safe conduct this afternoon.

IBN AL-MUQAFFA: Listen to the wind in the palms.

ASIA: I've known that sound since I was a child.

IBN AL-MUQAFFA: My mother used to call it the sound of the moon crying.

ASIA: Why was the moon crying?

IBN AL-MUQAFFA: Because it was sad.

Enter AL-MANSOUR, reading a copy of the tales.

SUFYAN: Don't be sad, I've gathered your friends for you.

IBN AL-MUQAFFA: I see.

SUFYAN: White robe please. This is your trial.

IBN AL-MUQAFFA: My trial.

SUFYAN: Any more gags before we begin?

IBN AL-MUQAFFA: Gags?

SUFYAN: 'You and your nose, Sufyan'; 'Promiscuity is a divine trait that opens in its opening' – that sort of thing? In Basra we don't forget what poets say in public.

IBN AL-MUQAFFA: I am a prose writer, not a poet.

ABU AYYOUB: Modesty, at last!

SUFYAN: That's not our concern. Now, let's start. I, Sufyan, Governor of Basra, have been asked to try Abdullah Ibn Al-Muqaffa on charges of heresy. I think that's right, pig?

ABU AYYOUB: Absolutely.

IBN AL-MUQAFFA: Who brings these charges against me?

ABU AYYOUB: The Governor of Basra.

SUFYAN: Me!

IBN AL-MUQAFFA: This is ridiculous.

SUFYAN: Yes! This is the prosecution and this is the defence, chip in when you feel like it, it's a form of dialogue known as the prison.

ABU AYYOUB: Prism.

SUFYAN: Let's begin.

ABU AYYOUB: In the third tale the Lion has laws dictated to him by the Tiger who is the judge. Are you proposing the imposition of laws upon the Calipha, when in reality, the

Calipha is the source of all legislation in the lands of the Faithful.

IBN AL-MUQAFFA: The tale proposes the idea of a legal system, independent from the state itself, in which the Calipha is a part.

ABU AYYOUB: Are we to believe, then, that there is a concept of state beyond the Cali –

IBN AL-MUQAFFA: I didn't make it up you can read it in Aristotle!

SUFYAN: And these, this detestable handbook for heretics, did you not write that either?

IBN AL-MUQAFFA: I wrote some prose in imitation of the Koran.

SUFYAN: To pretend the Koran could be written by a human hand?!

IBN AL-MUQAFFA: No! As practice sheets, to improve my style.

SUFYAN: Your style needs much improvement. An eye please, pluck out an eye.

ABU AYYOUB: I object my Lord, the trial is not over!

IBN AL-MUQAFFA: What are you doing?

SUFYAN: Just one little eye, please. I can't possibly focus on both of them.

IBN AL-MUQAFFA: Sufyan, I warn you, he will hear of it!

SUFYAN: The Calipha's ears have been burnt by your vile words!

White blossoms begin to blow across the stage as SUFYAN's men gouge out IBN AL-MUQAFFA's eye.

ABU AYYOUB: In the story of the rat in the fifth tale, you propose that there are two types of rats: rulers and ruled.

SUFYAN: As opposed to?

ABU AYYOUB: Believers and non-believers.

ASIA: Look! (*She runs towards the blossoms.*) The moon is throwing blossoms at our feet. Look, Ibn Al-Muqaffa, look!

IBN AL-MUQAFFA: Hold my hand would you, my love? My love?

SUFYAN: Hands to the wrists.

Enter JUDGE, joining AL-MANSOUR.

AL-MANSOUR: Judge, not in white?

JUDGE: My Lord, the town is racked with fear, every mouth utters a contrary tale, Ibn Al-Muqaffa's disappearance is too dark for the white robe.

AL-MANSOUR: Then I will judge.

JUDGE: As you wish, my Lord.

AL-MANSOUR: Any witnesses?

JUDGE: Plenty. All of whom claim to have seen Ibn Al-Muqaffa entering into Sufyan's house.

AL-MANSOUR: Does my Governor in Basra stand accused because a man entered his house? Any trace of the body?

JUDGE: None.

AL-MANSOUR: How do you explain that?

JUDGE: Martyrs, my Lord, have a habit of leaping out of graves.

AL-MANSOUR: Philosophically, then.

JUDGE: It is my duty to tell you, my Lord, that many leading citizens in Basra including theologians, merchants –

SUFYAN: Feet to the ankles.

JUDGE: – poets, landowners –

SUFYAN: Roast that piece. He'll try it.

JUDGE: – and scientists want Sufyan punished for what they claim they know he did to Ibn Al-Muqaffa.

Enter ABDULLAH, crawling.

ABDULLAH BIN ALI: (*Repeating.*)
Help. Help. Long live Al-Mansour.
Help. Help. Long live Al-Mansour.

AL-MANSOUR: Do you have a signed petition?

JUDGE: I do

AL-MANSOUR: How many live in Basra, do you know?

JUDGE: Fifteen thousand, my Lord.

AL-MANSOUR: And how many are on this petition?

JUDGE: Twenty.

AL-MANSOUR: I'll see them, if you don't mind.

IBN AL-MUQAFFA: (*Mumbling.*)
 With this life you force a thousand souls to die,
 but when your time comes, Sufyan, not one will spare a sigh.

SUFYAN: Man's attachment to poetry in the face of horror is, is it not, depravity itself?

AL-MANSOUR: They want Sufyan's blood for Ibn Al-Muqaffa's?

JUDGE: They do.

AL-MANSOUR: And what if I gave them that and then what if Ibn Al-Muqaffa appears through that door there? Which one of their blood should I then take for Sufyan's?

Exit JUDGE.

White blossoms cease.

Enter ASIA.

BASHAR: When the Lion spoke these words the animals conferred and terror, like a pestilent breeze, passed through them. One by one, then in droves, they left the palace each with their heads down. That night was still as a bone and bowls of water in silent courtyards turned untouched the colour of blood.

ASIA: Please God give my tongue power to curse you Al-Mansour! May your children rip out their father's eyes, and may the Turk, the Christian and the Jew drag your offspring through the streets riding imperial on chariots of gold and shred your lands between them like thin pieces of ribbon, may the heavens pour scorching flames onto your cities and your rivers be forever choked with floating corpses, may all

your libraries be burnt and all your streets swell with rapists and murderers. If Iraq obeys Al-Mansour, then may Iraq never thrive, may its soil from this day forth churn out only tyrants, all its gardens be riddled with assassins and may the cries of all its children be like so many senseless rocks in the desert from this day to the farthest reaches of time, please God hear what I have spoken!

AL-MANSOUR: Silence! Let me hear that resonate.

END

Glossary

OF NAMES

AL-SAFFAH: Literally, 'The Blood Shedder'.

AL-MANSOUR: Literally, 'The Victorious One'.

MARWAN: Last Calipha of the Ummayid Dynasty; Marwan, forced to flee his capital city, Damascus, by the advancing Abbasid forces, was killed by Abdullah Bin Ali in Egypt.

OF PLACES

AL-ANBAR: First Capital of the Abbasid dynasty.

BASRA: Circa 750 AD, Basra was the undisputed literary, scientific and academic centre of the Islamic world. Basra was where scribes trained, philosophers translated from the Greek, Indian and Persian and theologians debated on free will and divine destiny.

BAGHDAD: In 762 Al-Mansour founded a new capital on the site of the old village of Baghdad. It was officially known as Madinat al-Salam ('City of Peace'), but in popular usage the old name prevailed. Baghdad soon became larger than any city in Europe or western Asia. Al-Mansour built the massive Round City with four gates and his palace and the main mosque in the centre. The symbolically-charged round plan epitomizes the incorporation of eastern models of kingship into a new architectural ethos.

KHURASAN: It was from Khurasan, the north-eastern province of Persia, that Abu Muslim unfurled the black banners announcing the rise of the Abbasid revolt in 747 AD. In reward for this, Abu Muslim was later appointed governor of this highly significant province.

OF RELIGIONS AND TERMS

ZINDIQ: The Arabic term comes from the Persian word *zand*, a word used to designate the ascetic followers of Mani (Manichaeists). In Arabic, this term began its etymological life meaning 'decadent' and was frequently used of poets and 'free-thinkers' like those within the circle of Bashar Ibn Burd, notorious for their wine drinking and dissoluteness. As religious orthodoxy gained power, the term became synonymous with heresy and punishable by death. The purge against *zindiqs* reached its bloody height during the rule of Al-Mansour's son who had Bashar Ibn Burd put to death on this charge. Equally, later apologists for Ibn Al-Muqaffa's murder accused him retrospectively of being a *zindiq*.

MANICHAEISM: Dualistic religious movement founded in Persia in the 3rd century AD by Mani, also known as the 'Apostle of Light' and supreme 'Illuminator'. Two radically opposed substances inform its mythology: Spirit and Matter, Good and Evil, Light and Darkness. Ibn Al-Muqaffa was a Manichaeist before his conversion to Islam.

ROUMS: The Christians.

MAZDAK (MAZDAKIAN): Dualistic religion that arose in Iran in the late 5th century AD. It is named after Mazdak, its Persian founder. The religion was soon suppressed by nobles and clergy who objected to its tenets concerning the common holding of property and women. Regarded today as a primitive form of communism, it survived secretly until the 8th century.

SABIANS: Religious group known to worship The Glorious Names of Allah (El-Esma'a) as the stars.

Printed in the USA
CPSIA information can be obtained
at www.ICGtesting.com
LVHW020900171024
794056LV00002B/637